THE LIFE AND DEATH OF BUILDINGS

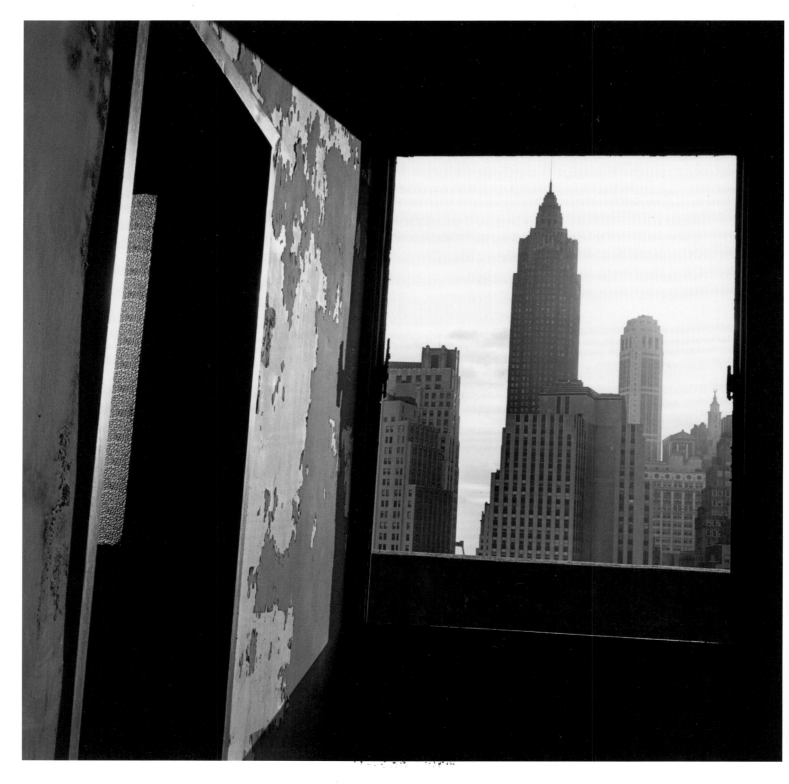

THE LIFE AND DEATH OF BUILDINGS

On Photography and Time

JOEL SMITH

Princeton University Art Museum

Distributed by Yale University Press

New Haven and London

The Life and Death of Buildings: On Photography and Time is published by the Princeton University Art Museum and distributed by Yale University Press, New Haven and London.

Princeton University Art Museum
Princeton, New Jersey 08544-1018
artmuseum.princeton.edu

Yale University Press
P.O. Box 209040
302 Temple Street
New Haven, Connecticut 06520-9040
www.yalebooks.com/art

This book is published in conjunction with the exhibition *The Life and Death of Buildings*, on view at the Princeton University Art Museum from July 23 through November 6, 2011.

Support for this publication has been provided by the Andrew W. Mellon Foundation and Annette Merle-Smith. The exhibition and related programming have been supported by the Kathleen C. Sherrerd Program Fund for American Art; the National Endowment for the Arts; the Peter Jay Sharp Foundation; Christopher E. Olofson, Class of 1992; the Frances E. and Elias Wolf, Class of 1920, Fund; an anonymous supporter; the Allen R. Adler, Class of 1967, Exhibitions Fund; the Judith and Anthony B. Evnin, Class of 1962, Exhibitions Fund; the Robert Mapplethorpe Foundation; the Frederick H. Remington, Class of 1943, Trust, and the Friends and Partners of the Princeton University Art Museum.

Managing Editor: Jill Guthrie
Project Editor: Sharon Herson
Designer: Margaret Bauer,
 Washington, D.C.
Printer: Brilliant Graphics,
 Exton, Pennsylvania

The book is typeset in Adobe Jensen Pro and Kievit Pro and printed on Scheufelen PhoeniXmotion Xantur 100 lb. text and Garda Silk 130 lb. cover.

Library of Congress Control Number:
2011924444

ISBN: 978-0-300-17435-9

Illustrations:
front cover: Lynne Cohen, *Motel Room*, 1979
front flap: Julian Faulhaber, *Ceiling*, 2006
back cover: Andrew Moore, *Model T Headquarters, Highland Park*, from the series *Detroit*, 2009
back flap: Charles Clifford, *Burgos Cathedral, Façade*, 1853, detail

Printed and bound in the United States of America

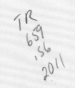
FRONTISPIECE
Danny Lyon, *View south from 100 Gold Street*, from *The Destruction of Lower Manhattan*, 1967

OPPOSITE
Unknown French photographer, *Universal Exposition of 1900, Paris: Pavilion of Ecuador*

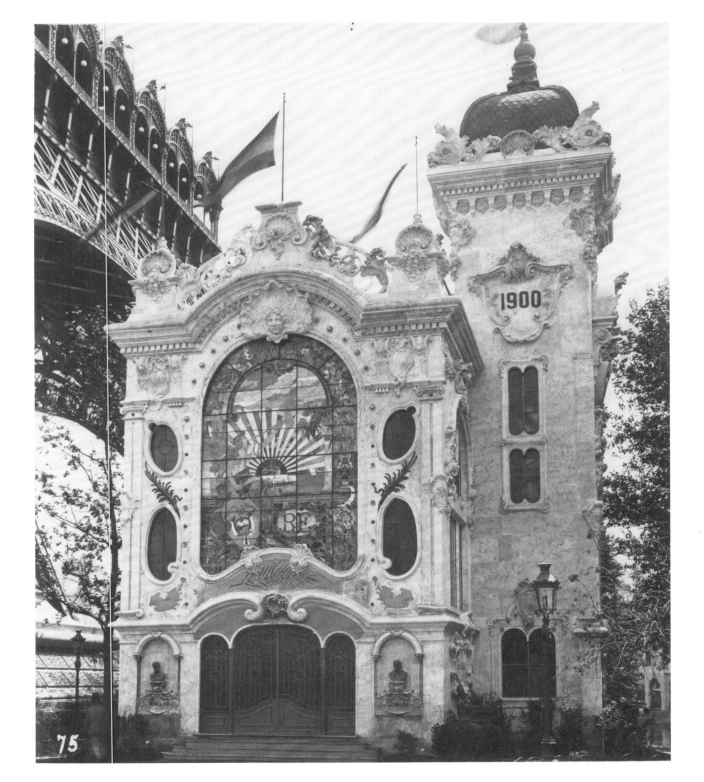

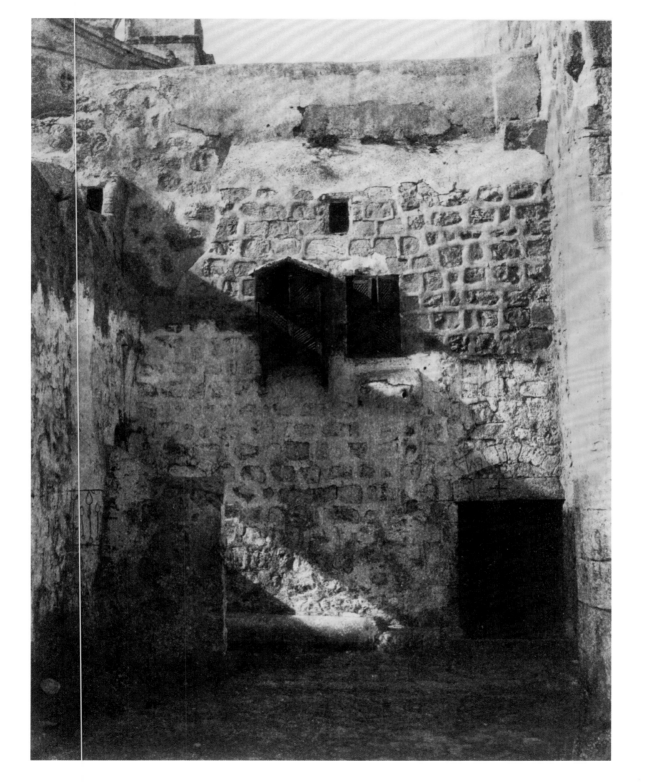

Human memory is a faculty under siege. As historical literacy declines, attention spans shrink to fit an accelerating news cycle and new modes of information delivery; the past is thinned down into entertainment "based on real events," and what has been called a "memory industry" keeps the civic calendar booked with a parade of commemorations. Under such conditions, art museums face a daunting challenge: how to engage viewers in dialogue through, and with, genuine objects of the past — a past that, in its singularity and materiality, seems to recede ever further from everyday life in the digital age.

In this book and the exhibition it accompanies, Joel Smith examines some of the ways in which the past, far from disappearing from our lives, is perpetuated and reinvented by two of the most common genres of "artifact" all around us — the building and the photograph. His project was sparked in 2008 when Robin Krasny, Princeton Class of 1973, offered the Princeton University Art Museum a complete set of Danny Lyon's 1967 series of photographs, *The Destruction of Lower Manhattan*. In its seventy-two images, Lyon documented the razing of the modest mid-nineteenth-century neighborhoods of New York that fell so that giant new structures, including the World Trade Center, could take their place. The reissue of the series by the artist in 2005, half a decade after the attacks on the Twin Towers, could not help but convey a different message about time, transformation, and loss than it had when first published.

While gratefully accepting Krasny's offer, Smith wondered: what would it mean to see the post-9/11 shift in meaning of *The Destruction of Lower Manhattan* as an authentic facet of the work? Could one understand the series as a traveler through history, like a building that stands on a changing block, its meaning deepening with nuance as the neighborhood evolves, so that — as Smith has come to suggest of virtually all architectural photography — history "has become its coauthor"? With this question in mind, he began to excavate in and expand upon the Art Museum's photographic holdings, and also to look beyond both the medium and the Museum for compelling objects through which to contextualize

The Destruction of Lower Manhattan and, ultimately, to construct *The Life and Death of Buildings*.

In turn, *The Life and Death of Buildings* served as a catalyst for a collective investigation, spanning most of the 2011 calendar year and involving numerous organizations across Princeton University and the greater Princeton community. Exploring the power of the arts to shape a sense of our collective or cultural memory, this investigation asks questions such as how art can decipher loss and inform our experience of global events. Under the collective title *Memory and the Work of Art*, it includes an array of exhibitions (some based in the Art Museum, others elsewhere in Princeton), concerts, performances, and lectures. Through both this exhibition and this very special collaboration, we are reminded, more than ever, of the Museum's inestimable good fortune in serving an extraordinary university and community. It is with warmest gratitude to all of our partners that we will look back on an unusually rewarding year of collaborations and on an exhibition that challenges us to look freshly at the meanings of time.

JAMES CHRISTEN STEWARD
Director, Princeton University Art Museum

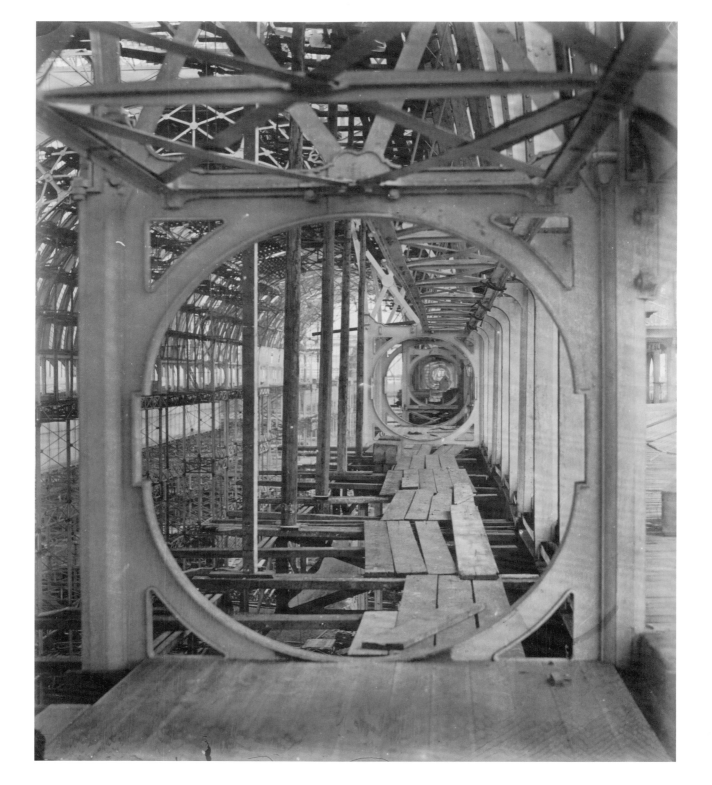

I was first inspired to attend to the dialogue between buildings and photographs by a generous gift offer from M. Robin Krasny, Class of 1973, and it is now my privilege to share what her gift made possible. The ensuing project has been made possible by the artists, donors, and lenders named in the checklist, with special thanks to Mike Williams, Richard and Ronay Menschel, and Janet Bishop, curator of painting and sculpture at the San Francisco Museum of Modern Art, for their extraordinary efforts. I am pleased to acknowledge the committed support of the Andrew W. Mellon Foundation; Annette Merle-Smith; the Kathleen C. Sherrerd Program Fund for American Art; the National Endowment for the Arts; the Peter Jay Sharp Foundation; Christopher E. Olofson, Class of 1992; the Frances E. and Elias Wolf, Class of 1920, Fund; an anonymous supporter; the Allen R. Adler, Class of 1967, Exhibitions Fund; the Judith and Anthony B. Evnin, Class of 1962, Exhibitions Fund; the Robert Mapplethorpe Foundation; the Frederick H. Remington, Class of 1943, Trust; and the Friends and Partners of the Princeton University Art Museum.

Among the many Museum colleagues to whom I am grateful, special thanks are owed to associate director Becky Sender, for her oversight and moral support; photographer and digital imaging specialist Jeff Evans; manager of collection information and access Cathryn Goodwin; managing editor Jill Guthrie; preparator Mark Harris; project coordinator and associate registrar Alexia Hughes; and intern Sarah J. Kinter, Class of 2012.

For their invaluable contributions, I am indebted to Margaret Bauer, Mia Fineman, Sharon Herson, Bruce M. White, and the book's anonymous reader.

JOEL SMITH
Peter C. Bunnell Curator of Photography, Princeton University Art Museum

OPPOSITE
Philip Henry Delamotte,
The Upper Gallery, Crystal Palace, Sydenham, 1854

ABOVE
Gordon Matta-Clark, *Splitting: Four Corners*, 1974

OPPOSITE
Peter Keetman, *Baustelle (Building Site)*, 1954

Notes begin on page 88.

Buildings embody time. When a structure was first fixed to the ground and endured, humanity moved out of nature and into history. We have lived there ever since. The past, which in conventional language lies "behind" us, in reality surrounds us. History confers language, myth, and customs, and with them a durable past made of stone, wood, and glass. The history we inhabit in buildings is no comprehensive archive; it is a patchwork of survivals, a discontinuous and evolving collage. Still, the building, of all varieties of artifact, represents continuity of an important kind: that of location. Civilization grows around the building like coral around an island. A new-laid foundation expresses hope in the future of a plot of land; an abandoned building signifies a surrender. Gordon Matta-Clark's sculpture *Splitting: Four Corners* carries emotional weight because it is not a representation of the roof corners of a house but the corners themselves, sawed from the body of a structure given up to decay on a street in Englewood, New Jersey. Through these fragments speak the values of a society, measured in lives and decades. Whether pyramid or gas station, a building, in its immobility, imbues its locale with accumulated years, connecting the present to its moment of origin. Buildings embody *durational* time.

Richard McGuire, *Here*, 1989, detail

Danny Lyon, *The St. George Building* and *A week later. Women search for the Beekman Hospital*, from *The Destruction of Lower Manhattan*, 1967

Photographs are made of time. The time in a photograph is *punctual*, the projection of a moment, or some moderately longer interval, in the past. A photographer chooses the time and the place that meet in a photograph, and makes many further choices that shape it, too; but what sets photography apart among pictorial media is history's participation in it. Whatever a photograph represents, it represents in time; it represents a thing by representing a state of the thing. Whereas a stick-figure drawing neatly represents "man," a photograph's "man" is always someone of a certain age at a certain moment. Because they are made of time, photographs, in the plural, are good at reflecting change, whether of a person's maturing face or of a building as it rises, or as it disappears.

The photographs of buildings in these pages were made by documentarians, artists, journalists, propagandists, hobbyists, itinerant studio operators, dealers in order-by-number souvenir views, and historic preservationists. Their pictures bear the shapes of their differing purposes. As rooted as photographs are in the motives that give rise to them, this book is no more focused on photographers' intentions than on the principles of structural engineering. The focus here, instead, is on the transit of artifacts through time. Photographs and buildings are at once the products, the vessels, and the cargo of history. The evolving neighborhood of a building, seasons or centuries after its construction, colors its meaning. Likewise, to engage with an old photograph in light of the prehistory or later fate of its subject (and, sometimes, to know how the photograph itself came to be used) is to understand facets of that photograph that are real but to which its maker had no access. History has become its coauthor.

Draftsmen enjoy line-item-veto control over what goes into a drawing, what will be altered there, and what will get left out. Photographers control the content of their images just as rigorously, but they exert much of that control all at once: after they have positioned the camera and opened the shutter, time steps in. Rarely has time left its autograph as unambiguously in an image as in Charles Clifford's 1853 view of Burgos Cathedral. The blurred hand of the clock on the façade shows that Clifford's exposure lasted about two minutes. By so legibly depicting the piece of time from which it is carved, the image functions as a *memento mori* — one that its human helpmate almost certainly did not set out to create.

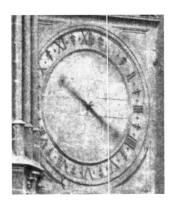

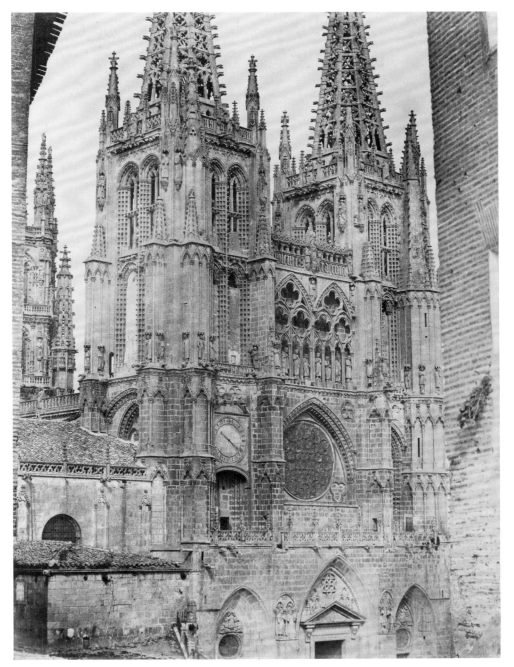

Charles Clifford, *Burgos Cathedral, Façade*, 1853, and detail

Ars longa, vita brevis. Duration is intersected by punctual time. The long, slow timescales of art, nature, and (presumptively) God are manifested in a great stone edifice, centuries in the making, while the quick passage of the exposure stands in for — and, in its triviality, caricatures — the ephemeral viewpoint of a mortal observer.

Architecture and Buildings As records — deposits — of the past, buildings and photographs are concrete instances of social memory in action: they are, from corner to corner and from subcellar to roof peak, impure fragments of the churn of time.

When completed under the emperor Hadrian in C.E. 125, the Temple of Olympian Zeus in Athens covered an area of over 4,400 square meters. But after the sack of the city in C.E. 267, the temple became a marble quarry for the locals. Its supply of massive columns, originally numbering 104, dwindled with the passing centuries. Only fifteen remained standing on the afternoon in 1858 when Dimitris Konstantinou, a maker of Athenian views, photographed the site. He placed his camera far enough away that his negative took in a three-story-high, stone-and-mortar structure perched atop the ruin: a "hut" built for ascetic hermits in the Middle Ages. Hellenists of Konstantinou's day regarded the hut as a blot on the ancient site, and they demolished it, along with many other traces of Byzantine Athens, in 1875. Konstantinou died the same year without photographing the altered temple ruin, but his assistant and studio heir, Konstantinos Athanasiou, found an ingenious way to update the studio's inventory: he painted over the hut on the old negative (erasing, in his zeal, the foremost bit of the temple's architrave) and began issuing new prints.

When someone alters a feature in a photograph, the act is likely to be described as a falsification of history. Buildings, though, undergo change and erasure all the time, with effects just as drastic on our access to and understanding of the past. To those accustomed to the old state of things, the new situation — the hutless temple or downtown Manhattan without the Twin Towers — will initially look as "false" and hallucinatory as a doctored photograph. But in time we catch on: the past we knew has been traded for a new past, as provisional as the old one. Those

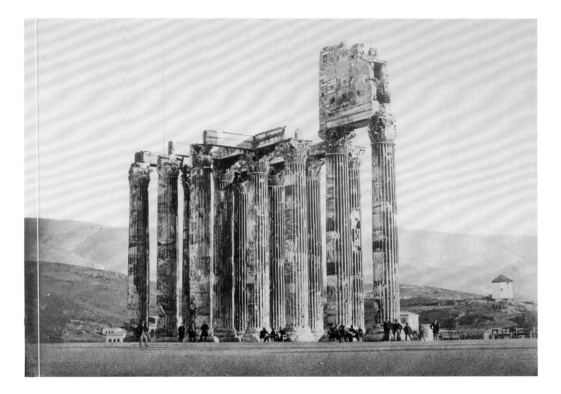

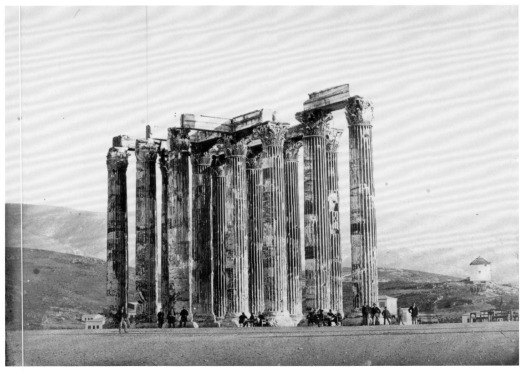

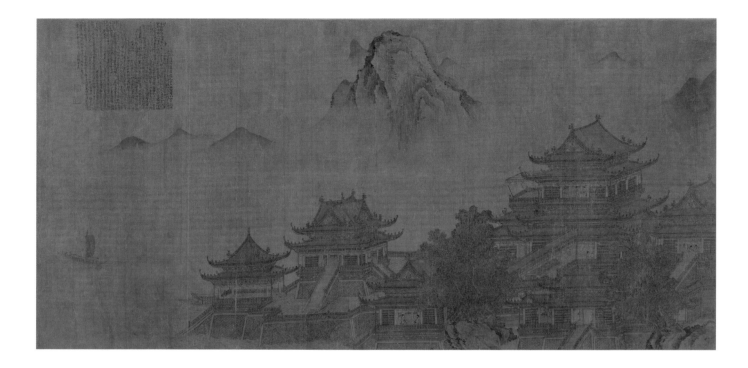

who never knew the hut at first hand might never suspect it existed, unless they come across its ghost in a photograph.

"Architecture" and "building" are not synonymous. One way of getting at the difference between them is to say: a building can be photographed. Architecture is a vast immaterial kingdom, a network of learning, taste, and commerce uniting art, trade, and a universe of ideas. Buildings, on the other hand, are things; they block the sun, displace roads, and shape human lives, sometimes for generations.

The Pavilion of Prince Teng, in China's Jianxi Province, was erected in the seventh century by Li Yuanying, a brother and uncle to emperors. Subject to fire, structural failure, war, and flood, the Pavilion has fallen and been rebuilt nearly thirty times. It rose most recently in 1989 as a tower of reinforced concrete. Through its many incarnations, the Pavilion has maintained both its status as an architectural paragon and its titular identity. Underwriting the authority of the incumbent tower (however it looks and whoever built it) is a classic text, the

"Preface to *The Pavilion of Prince Teng*," composed by the poet Wang Po when the first Pavilion was twenty years old. The "Preface" has a history as literature in its own right and also as an inscription on many representations of later iterations of the Pavilion, including Princeton's Yuan Dynasty rendering. The Pavilion of Prince Teng is, in effect, a cultural and conceptual tradition, substantiated by but not reducible to a structure that overlooks the banks of the river Gan. You can photograph what is there, but to see the Pavilion, look to the history told on silk and paper.

That is architecture; here is a building. During the reign of the Egyptian pharaoh Thutmose III (1479–1425 B.C.E), two obelisks dedicated to the king were raised in Heliopolis, near Cairo. Later — well over a thousand years later, between 23 and 12 B.C.E. — the Roman emperor Augustus had the pair moved to Alexandria, where he erected them facing the harbor in front of a temple to Caesar, the Caesarium, which Cleopatra subsequently rededicated to Marc Antony. (The obelisks' dedications to Thutmose III did not detract from these repurposings because nobody could read hieroglyphics anymore. Until Egyptologists deciphered them in the nineteenth century, they would remain illegible except as signifiers of an irretrievably remote past.) Over the centuries that followed, every last stone of the Caesarium was hauled away or buried. But looting a 224-ton obelisk is no minor task, and these two — dubbed Cleopatra's Needles — remained where Augustus had left them. In time, one toppled over. In the 1860s, Antonio Beato photographed the other one as he found it, hemmed in by modern neighbors: piers, a warehouse, the mast of a ship, a crude shack that blocks the camera's view. But Beato's record is not the end of the story. In 1881 the standing needle was taken to New York City and erected in Central Park, three years after its recumbent partner had been shipped to London and installed on the Thames Embankment. From dynastic Egypt to Roman imperium to Victorian England and Gilded Age America, the three-millennium migration of Cleopatra's Needles traces a history of empire from empire's beginnings to the present.

Architecture is an historical unity braided into the rise and fall of ideas, like those that tell the history that is the Pavilion of Prince Teng. The story of a *building*, though — as complex, compromised, or even ambulatory as that story may be — is a story of physical continuity, like that of the Temple of Olympian Zeus

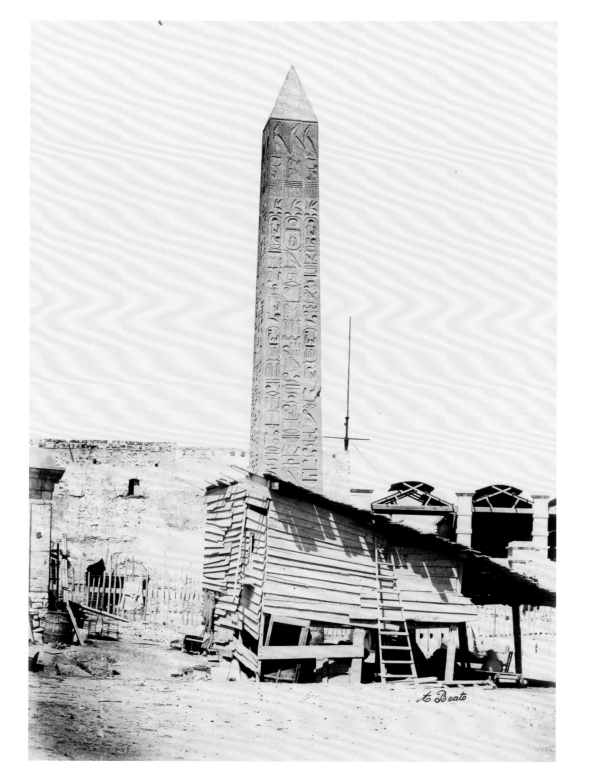

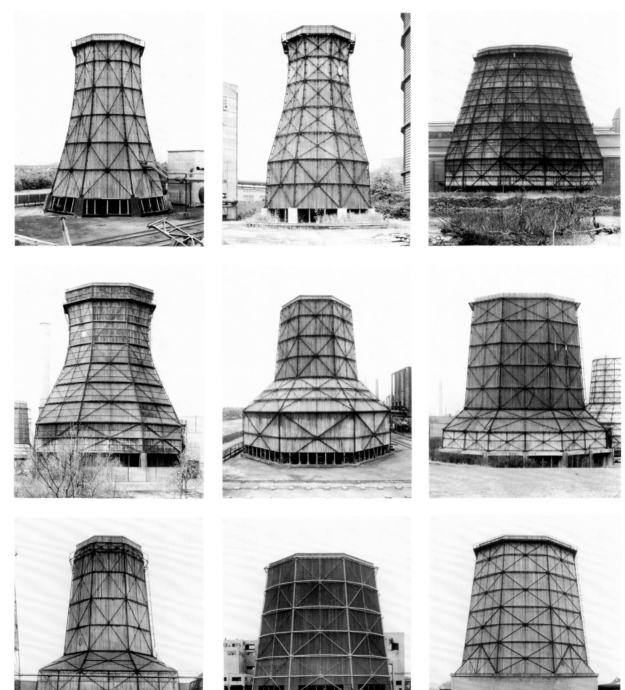

or of the obelisks of Thutmose III. Only a literary and conceptual tradition could weave a singular narrative out of the twenty-nine buildings that have "been" the Pavilion of Prince Teng. Likewise, in its brute factuality the camera is suited, as no other recording medium is, to confirm that the spire of stone casting a shadow today behind the Metropolitan Museum of Art once stood in Alexandria.

"That-has-been": so Roland Barthes memorably summarizes the message of a photograph. A photograph preserves a sectional outtake of the past — the core sample of a moment in Alexandria or two minutes in Spain. When the camera's subject is an enduring structure, the photograph accomplishes a kind of tunneling-through of space-time. Like Richard Misrach's *White Man Contemplating Pyramids*, each of us is subject to flashes of awareness of the depth of history embodied in a building. And yet the only segment of any building's history we can ever physically inhabit is our own. Photographs, by embodying moments of time in the punctual crossings of space, light, and surface, take us as close as we ever get to time travel.

Time, Place, Detail The time and space in a photograph are at once traces of real space-time and mere forms on paper, put there by a craftsman. Through discrete mechanical choices, the photographer of a building can make a point of singling it out or lay stress on the relationships that define it as a place in the world. Closeups steer the eye into an engagement with form, structure, and surface, while landscape views, dense with interconnected details, set the eye in motion and stir the narrative and historical imagination to life. Either mode of emphasis reflects choices made in the field. You can step so close in that you become a player in the scene or adopt the removed perspective of a surveyor. You can use a lens that takes in a view wider or narrower than the eye's forty-five degrees, and thereby encourage the eye to roam or rest. You can expose a scene so quickly that passersby are fixed like statuary or so slowly that movement renders them ghostly, or prevents them from even registering on the plate.

The isolationist extreme is epitomized by Bernd and Hilla Becher's typological studies of industrial structures as "anonymous sculptures." With each image in their nine-frame grid of cooling towers, the Bechers pluck a tower out of its

workaday setting and fit it into a new context whose parameters are wholly photographic. By combining the grid format with a consistent compositional template for each image — low horizon, laterally centered subject, blank sky for a backdrop — they inspire an addictive game of compare-the-towers. Within each of these nine pictures the voice of time is muted; the Bechers' close cropping puts each tower closer, literally, to its typological siblings than to the real-world setting where it once participated in a history and a mechanical process.

During the same expeditions to mining and manufacturing centers where they exposed their typological studies, the Bechers made large, horizontal-format views they called "industrial landscapes." Their rooftop overview of Gelsenkirchen, in Germany's Ruhr Valley, includes two winding towers, three cooling towers, and a factory façade: a localized sampling from several of the Bechers' typological series. Like celebrities spied at a restaurant, these familiar figures are at once normalized and made doubly strange by restoration to their real-life context. Inserting them back into space returns them to time, for the sweeping space of the landscape prompts an optical walkabout that lays the pathways for mental narrative. The street and rail yard, the residences lining the road, and the configuration of the plant itself invite one to read Gelsenkirchen as a stage where action unfolds. The generous scale of the print encourages an immersion that yields details native to the passing moment: a distant pedestrian, three men watching for a train, a puff of white chimney smoke. Through the marriage of broad scope and intimate incident, the Bechers, like Bruegel before them, make a pictorial subject of the incremental ticking-away of historical time.

The social nature of buildings can sometimes be conveyed in one telling detail. Edward Ranney's view at Machu Picchu portrays a jutting outcrop of stone that was sculpted by Inca builders into service as a floor and stepped wall. Scholars have suggested that "integrated outcrops" such as this one served to effect a literal marriage between site and building, thus securing the Earth's consent in Inca affairs, notably assimilations of new territory. The outcrop is thus at once a functional feature of construction and the familial contract that justifies the construction: it is, so to speak, both the Dome of the Rock and the Rock itself. Through framing, lighting, and exquisite printing that sets the outcrop off from its

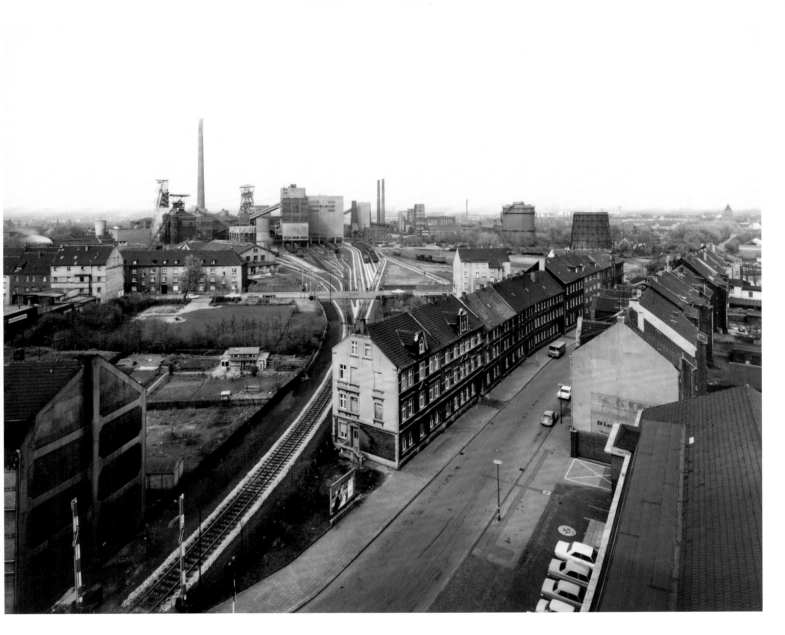

Bernd Becher and Hilla Becher,
Zeche Consolidation, Gelsenkirchen,
Ruhr, Germany, 1974

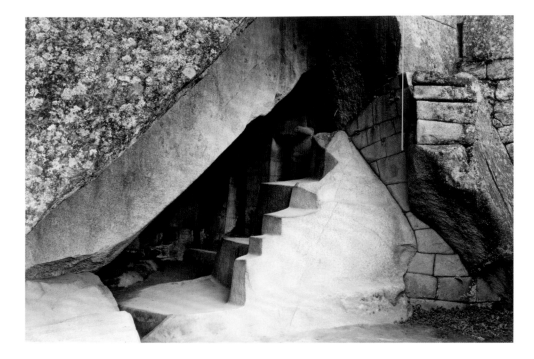

neighboring stones, Ranney accentuates both its structural integration and the eccentric form that advertises its unique status.

In a photograph made at Chichén Itzá in March 1932, Laura Gilpin recorded — for the first time ever, as it would turn out — a semiannual intersection of local and cosmic geography on the face of the pyramid of Kukulcán. In the days surrounding the spring and fall equinoxes, sunlight on the flank of the pyramid's north staircase assumes the form of seven downward-pointing triangles, resembling the pattern on a rattlesnake's back. The triangles drift toward the sculpted serpent's head at the base of the balustrade, as if the plumed serpent, Kukulcán (Quetzlcoatl), were slithering to earth. Today the event draws large tourist audiences and is read as a sign of Mayan astronomical prowess. It is possible, however, that it is purely a product of modern construction. For Chichén Itzá lay abandoned for centuries. When ground clearing began there, the pyramid of Kukulcán was a steep, over-grown jungle hill; the stones that now compose the north balustrade were assembled from rubble gathered at the base of the pyramid by masons who worked with

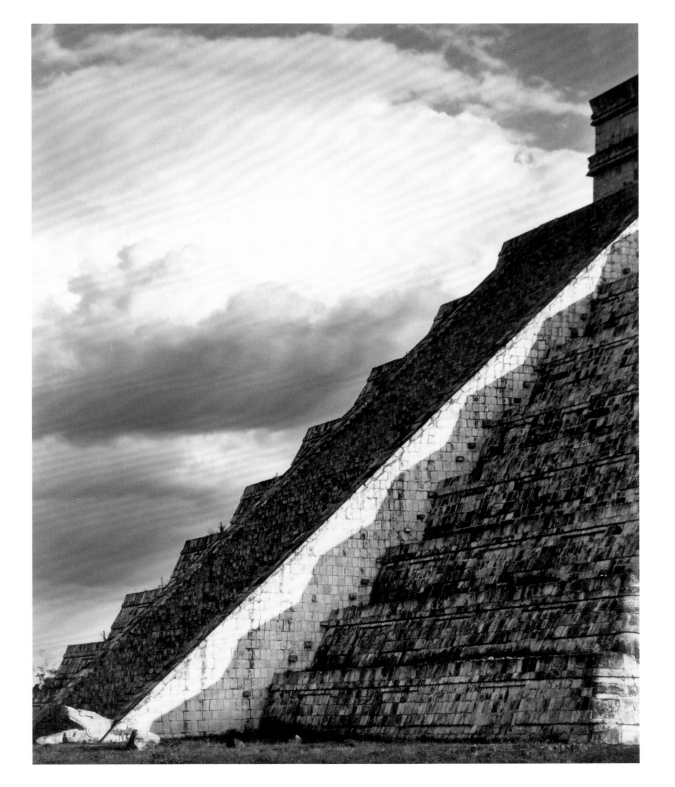

little archaeological oversight. What did Gilpin record in the moment she exposed her image: a phenomenon of cyclical time, resurrected through reconstruction, or an opportune accident ripe for mythification? What convenience leads us to regard, in photography, as a language of fact is really a physics of light, and sometimes it is light itself that poses the puzzles of history.

Houses No purpose is more fundamental to building than providing shelter. The cave, the hut, the tent, the lean-to, even protective clothing — all figure in speculative genealogies of the house. Whether or not the clan or family dwelling was literally the first type of building to be erected, the house still holds first place in personal experience, in the psyche (in dreams, for example), and in myth. Carleton Watkins's view of the "Pioneer's Cabin" redwood tree in Calaveras County, California, records one of the many places where natural topography has been drafted into local legend about the origins of human settlement.

The North American prairie was settled (or rather resettled) through thousands of reenactments of a primal story: a landless peasant takes to the wilderness, builds a house, and starts farming. Beginning in 1862, successive federal Homestead Acts promised a parcel of arable land to anyone who staked a claim and inhabited the spot for five years. With the spread of Rural Free Delivery in 1902 and the introduction of mail-ready, postcard-backed photographic printing paper in 1906, itinerant photographers who plied the plains began offering homesteaders the means to send their loved ones a word, and an image, to say how they were faring. As an object, the claim-shack postcard is as rooted in pioneer individualism as the gumption and house-pride it documents. A typical card was sent by mail from its subject to a friend or relative; was rarely seen by more than a few people; and then disappeared into an album or shoebox without going on to greater glory as part of any public archive. Only generations later, as these and other family photographs came to be accumulated in number by collectors, could they begin to tell a collective narrative of mass migration and settlement, in which tents give way to sod huts or tar-paper shacks, and eventually to houses with windows, livestock, and even the rare shade tree.

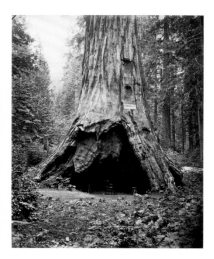

ABOVE
Carleton Watkins,
Pioneer's Cabin, 1865/66

OPPOSITE
Unknown American photographers,
Homesteaders with claim shacks,
1907–1920s

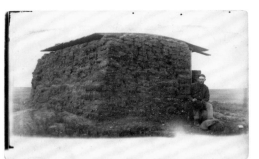
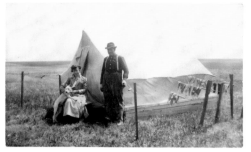

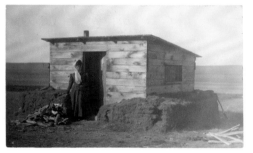
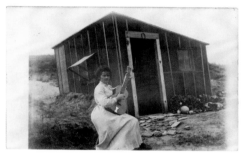

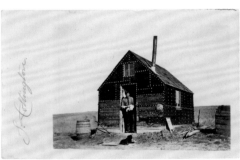
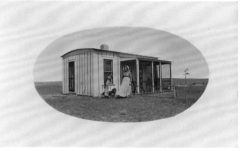

arthur. by his "mansion" on the plains of Wyo. H.D.S.

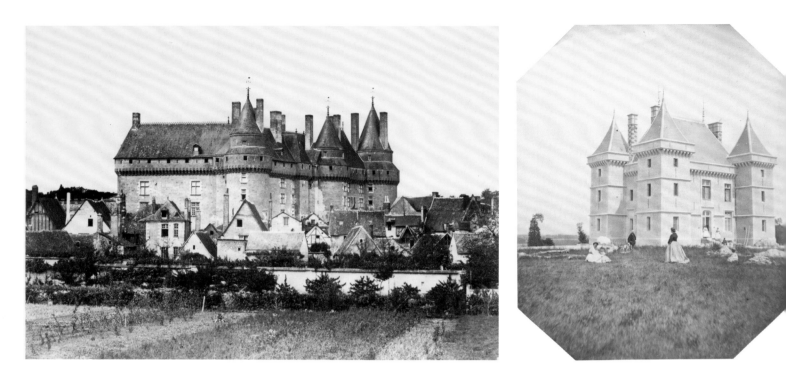

In Europe, photography presented homeowners with a different kind of past. In the 1860s, while Eugène Viollet-le-Duc was leading an ongoing appraisal of France's Gothic-age patrimony, a maker of souvenir views named Gabriel Blaise took his camera to the edge of the town of Langeais and photographed its fifteenth-century château. Blaise portrays the château as the soul of the town, held in the close embrace of Langeais's houses and fields. The ideal of aristocratic splendor, if not the idyll of communal integrity, is echoed in a second photograph made around the same time, depicting what is clearly a brand-new residence in the countryside. The design of the house, from its chimneys and turrets to the decorative "arrow slits" punctuating its walls, is plainly indebted to the stately château. The camera operator may well have been the homeowner; the surplus of lawn that is allowed to fill the foreground suggests an amateur is feeling his way, and photography was a suitable hobby for the kind of haut-bourgeois who built his family a castle at the end of the branchline.

By 1936, the home-as-castle ideal had taken a technological turn. New Yorkers paid a dime apiece to tour the House of the Modern Age, a commercial builders' showcase in midtown that featured air conditioning, labor-saving appliances, and a circular formica bar. Berenice Abbott photographed the House as just what it was, a footnote amid the towers of midtown. (Three of those towers bear late, absurd fruit of Viollet-le-Duc's gothicizing impulse: a mansard roof, church-top finials, and pointed windows that soar two hundred meters above street level.) Financially tenable only as a temporary gesture, the "$10,000 house on a million-dollar lot" existed only a few months before being demolished to make room for the next building with enough rental space to pay its way on Park Avenue. The future of the American single-family house looked less like Abbott's image than like

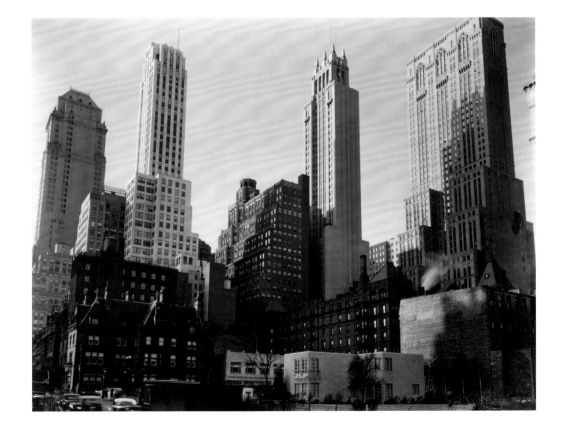

William A. Garnett, *Housing
Development, San Francisco,
California*, 1953–56

William Garnett's view of a gigantic development some twenty years later, in which the houses are a mob of lordless vassals, a labyrinth of mortgage-payers' claim shacks smothering the land.

The Destruction of . . . Most history occurs at a gradual creep, but sometimes it truly *happens*, and the rare photographer is lucky enough to land in front of it in time to bear witness. It happened for Danny Lyon in 1967. Two years photographing the civil rights struggle in the American South with the Student Nonviolent Coordinating Committee and another two photographing biker gangs had left him, at age twenty-four, feeling a deep need to "get away from people." Lyon retreated to a squat in lower Manhattan, a place that seemed to promise a quiet haven on the frontier of urban decline. Joining an informal band of internal exiles that included a sculptor friend, Mark di Suvero, he took up residence in one of the dozens of abandoned buildings in the vicinity of Wall Street.

Lyon soon noticed that hundreds of buildings on the nearby streets were barricaded and that wrecking crews were going to work on them. Some sixty acres of buildings south of Canal Street, many of them over a century old, were about to disappear, and clearly whatever took their place was going to be huge. (Among those projects was a complex of seven high-rises, already underway, that was to be called the World Trade Center.) Since the mid-nineteenth century, the area had hosted a working district of wholesale markets, warehouses, showrooms, and hotels. It boasted no landmark on a par with Penn Station (McKim, Mead, and White, 1910), the demolition of which, in 1963, had helped inspire New York's first statutes for historic preservation.

Despite Lyon's desire to take a break, a new documentary subject had found him. After equipping himself through connections at the Magnum photography agency and the New York State Council on the Arts, he began photographing the insides and outsides of the doomed buildings, the fast-changing streetscapes around them, and the crews of wreckers, whose attitudes toward their shaggy young observer ranged from amusement to hostile suspicion. Out of this work Lyon created a seventy-two-image book called *The Destruction of Lower Manhattan* (1969).

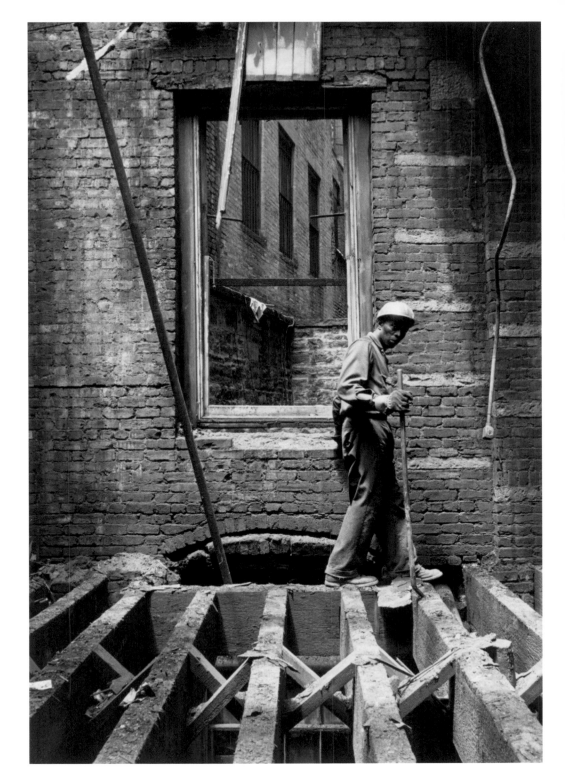

Lyon's social consciousness, honed by the challenges of civil rights work, may have helped him to recognize two underdog stories that were colliding before his eyes. One was a story about the wasteful loss of a human-scaled old neighborhood, of the very kind Jane Jacobs had defended in her influential book *The Death and Life of Great American Cities* (1961). The other story was about housewreckers earning a day's wage in a society where labor faced ever-narrower options. In Lyon's pictures, his dual sympathies are tempered by his mordant acceptance of contradiction — a sensibility that probably helped him take in stride a wrecking-crew foreman's vow to "drop a wall" on him at the first opportunity. That Lyon had this story to himself appears to have lent his work the added urgency of a personal cause, yet without forcing a framework upon him; no picture-story editor was waiting to see contact sheets, no field coordinator needed press prints.

Many of Lyon's *Destruction* images strike resonant chords with photographs made by others in quite different situations before him. These transhistorical echoes do not point to any direct "influence" of the art historian's kind. They testify, rather, to a humanistic habit Lyon and his predecessors shared: they were all inclined to regard both people and buildings as historic figures. For a photographer, reconciling these two types of actor, built and human, in one image, means thinking strategically about scale. In a corner-angle view of a metal-front building on Gold Street, Lyon adopts a strategy Francis Bedford used in 1862 at the Temple of Jupiter at Baalbek. To emphasize the scale of a famously gargantuan rock in the temple's foundation, Bedford included five people in the lower right corner of his image (and even cheated a bit by using small boys). Lyon, in roughly the same situation, settles for one pedestrian on the sidewalk. Through this shared bit of stagecraft, he and Bedford both manage to heighten the massive, dead-eyed ponderousness of their subjects. Another example: in book form, Lyon ends *Destruction* with its rawest image of ruin, in which the last standing pillars of a leveled hotel resemble the lonely columns of Karnak that star in countless nineteenth-century views. If Lyon is drawing an analogy between LBJ's Great Society and the overextended empires of the past, he is also offering a sardonic take on the unearned nobility of ruins in a photograph, where two thousand years of slow depredation and twenty minutes of clearing dust yield nearly identical effects.

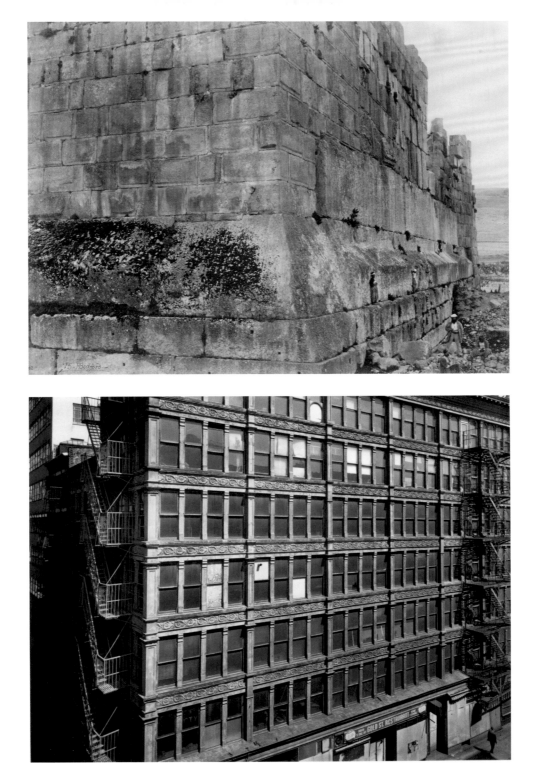

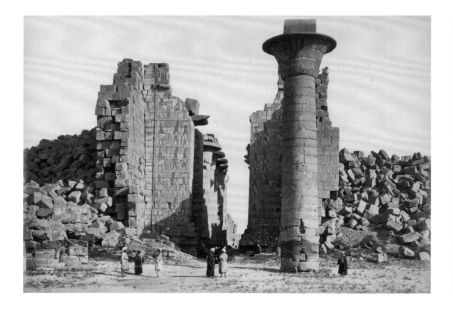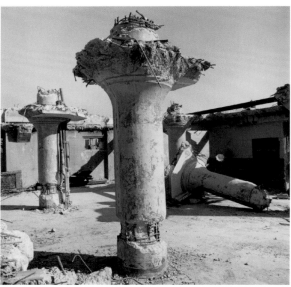

Most striking of all is a rhyme between Lyon's photograph of wreckers knocking over a wall and Lewis W. Hine's study of steelworkers assembling the girders of the Empire State Building thirty-seven years earlier. Though their pictures tell opposite (or, better, complementary) halves of the story of ground clearing and construction, Hine and Lyon agree in seeing the process as a labor of men, rather than a subject for aesthetic mystification (as in, say, a dramatic skyward-leaping perspective or a romantically sordid study of slag). Lyon's instinct to see labor as history, and vice versa, puts his work in conversation with Hine's progressive legacy. Lyon's concise 1969 text for *Destruction* concludes with a description of workers "risking their lives for $5.50 an hour, pulling apart brick by brick and beam by beam the work of other American workers who once stood on the same walls and held the same bricks, then new, so long ago." A similar historical echo links his own picture-making labor to that of earlier camera-bearing witnesses: fact-fishermen upstream from him on a river of time.

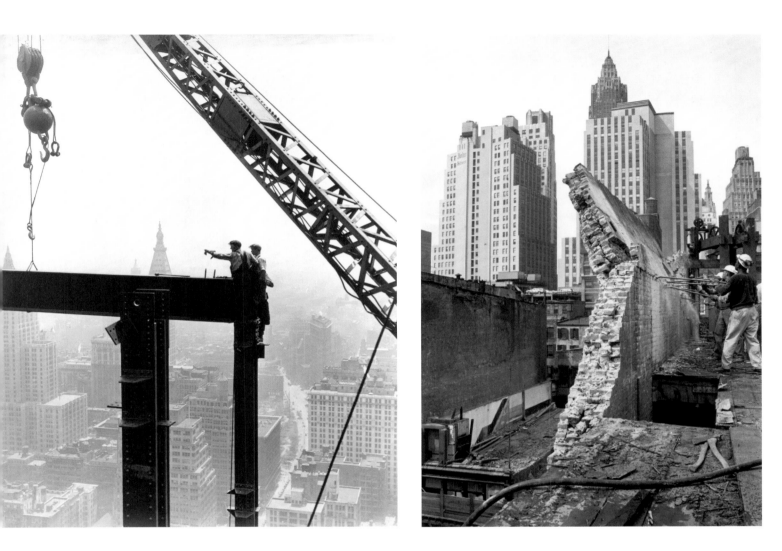

LEFT
Lewis W. Hine, *Laying a Great Beam* on the Empire State Building, 1930

RIGHT
Danny Lyon, *Dropping a wall*, from *The Destruction of Lower Manhattan*, 1967

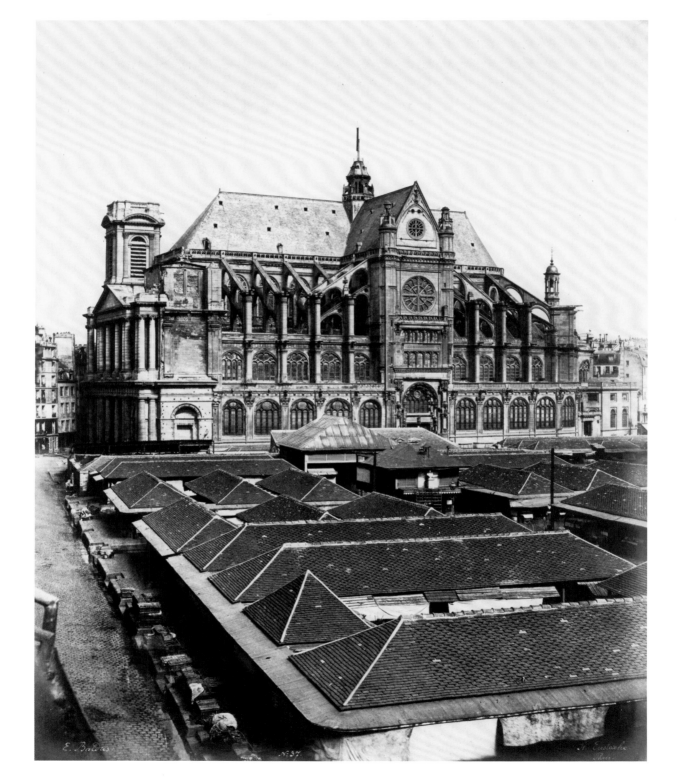

E. Baldus N° 37. St Eustache
 Paris

The Life of Buildings In the gap Lyon describes, between the day bricks unite and the day they scatter, falls the life of a building. Buildings live, or rather age, in our midst, but not as we do: not in the constant, one-way manner of bodies but according to the arrhythmic cycles of history. Yesterday's workplace becomes today's vacant eyesore and will be tomorrow's "timeless" protected landmark. Because our perceptions shift with the flux of history, the arc of a building's story is less apparent in real time than it becomes in retrospect, through images. In 1855, when Édouard Baldus chose a vantage point from which to photograph the Gothic church of Saint-Eustache, in Paris's first arrondissement, he had no reason to guess that viewers of a later era might take less historic interest in the church than in the low warren of merchants' stalls that fills the picture's foreground. It is safe to say he included Les Halles in his frame chiefly because it would have been harder to leave Les Halles out. Today the market stalls are gone, yet they are invoked constantly in the daily speech of the living. Though demolished in 1971, "Les Halles" lives on as a place-name for the neighborhood, its rail station (Châtelet les Halles), and the shopping center (Forum des Halles) beneath the park that now occupies the spot held for some seven centuries by the central market of Paris.

The opening and closing chapters of a building's life are prone to visual representation, in part because they are news and in part because their news is photogenic. Julian Faulhaber has discovered a rich vein of subject matter in rooms so new they lack any past, while Andrew Moore devotes his attention to spaces where human history, as it trails off, reveals it was only a parenthesis along the trajectory of natural history.

One could easily mistake Faulhaber's *Ceiling* for an image wrought in software on a keyboard. On the contrary, it is a straight photograph, made in a large-format film camera using only available light. But the artist has excluded any visual cue, such as wear or dust, that could be read as a firm indicator of human presence. Faulhaber's images are far from lifeless; the palette of *Ceiling* recalls the fresh, bright colors found in baby portraits. But, like babies, his spaces have the uncanniness of absolute innocence. The hyper-rational space in *Ceiling*, punctuated only by a smoke detector, is clearly human in origin, yet devoid of human experience. In the symbolic tradition that reads buildings as bodies (windows as eyes,

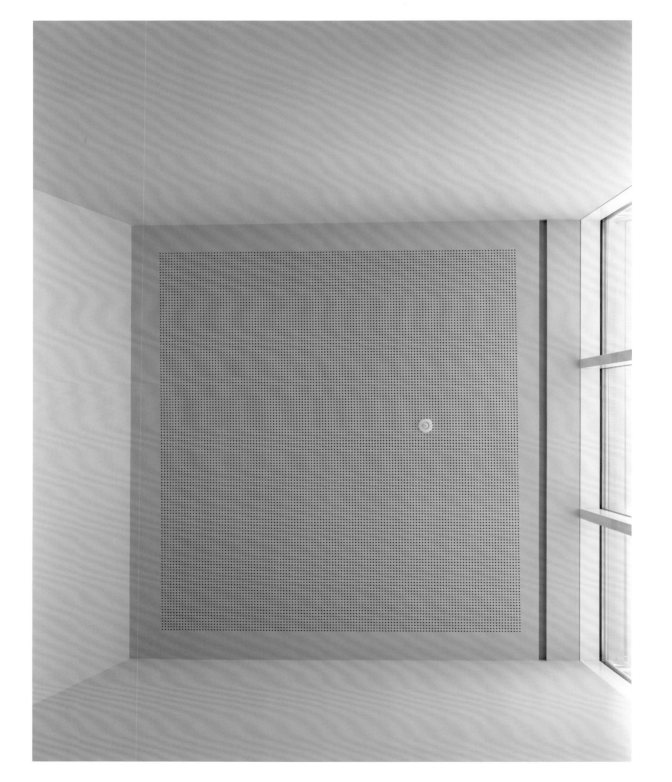

OPPOSITE
Julian Faulhaber, *Ceiling*, 2006

ABOVE
Andrew Moore, *Model T Headquarters, Highland Park*, from the series *Detroit*, 2009

43

doors as mouths), this view of the upper half of a pre-inhabited room is like a glimpse into the inscrutable mind of a newborn.

The metaphor of a building's "life" fails at the far end of the process, if rarely so vividly as in Andrew Moore's photograph of an executive office in Highland Park, Michigan, abandoned some forty years. Atop a crumbling staircase at Ford's onetime Model T Headquarters, Moore found a scene that looks like anything but death. The metallic walls of the room have bloomed in rust, making them look (if only in photographic translation) like mahogany paneling, while the carpeting has evolved into an old-growth forest of moss. Moore has also photographed trees growing out of a mulch bed of decaying books in a Detroit library warehouse and mounds of vine enveloping the last standing houses on city blocks that were, within living memory, densely populated. But getting overtaken by botany is not the only way buildings fail to "die." The pyramids, for example, have stood longer and known greater fame as ruins than they did as operative monuments; it may be, indeed, that on balance, ruins exercise a greater effect on collective imagination than buildings ever do in "life."

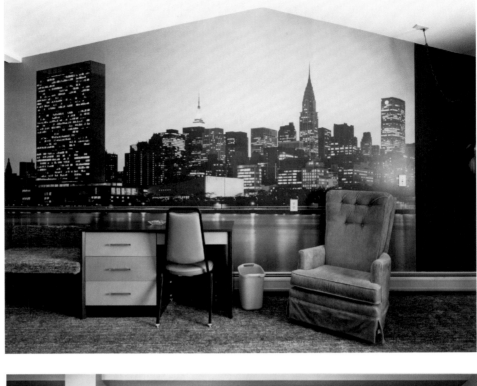

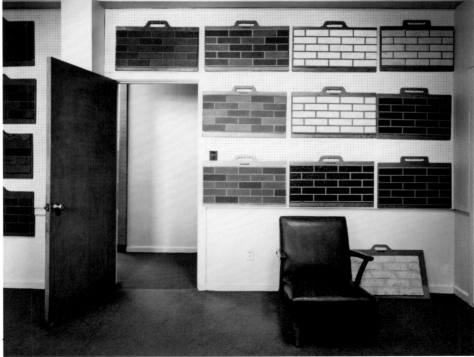

In a nod to the respect commanded by outward signs of age, new construction sometimes wears the fancy dress of the past. Until Gustave Eiffel made a case for the grandiose possibilities of the metal frame, European builders regarded it as something to hide. Thus Second Empire railway viaducts came clad in stone, revealing their iron underpinnings only as they were going up and again, decades later, as their costumes crumbled. (By 1930, it was intuitive for Lewis W. Hine to heroize the steelworkers of the Empire State Building because their medium, load-bearing steel, was recognized by then as a redemptively brilliant modern material, propelling civilization into the clouds.)

Interiors virtually always come clothed in fixtures and furniture, giving them the voice of a specific historical moment. In the 1970s Lynne Cohen began photographing North American "in-between" spaces, neither private nor entirely public, such as showrooms, laboratories, lobbies, and classrooms. Her unblinking view-camera confronts the surfaces of the culture straight on, and finds them all about as convincing and as dubious as a Manhattan skyline pasted to the wall of a motel room, or imitation-brick samples hanging in a salesman's office. Cohen has described the rooms that intrigued her as Duchampian readymades, "loaded with meaning" yet "incomprehensible." Her images combine clinical acuity with the random-sampling quality of time capsules: how could she have known what these spaces, often new and unremittingly banal, would say about their time later? She had no way to know. But finding America's interior full of false fronts (Naugahyde, veneer, polyethylene, shag), and perhaps seeing that its feverish self-deceptions looked both funnier and sadder in photographs, she set to work. The spaces and furnishings in her images paint the portrait of a civilization cut off from its past (it lacks even windows onto the present). Looking at many of Cohen's rooms in succession only deepens one's sense that the era's sole presiding spirit is that of disconnection.

History used to be easier to inhabit and harder to escape. In a view made in the early 1860s by the Fratelli Alinari, the west gallery of Pisa's Camposanto, an exhibition space for ancient sarcophagi and ecclesiastic sculpture, is crowded by the past. The central, dimly sunlit figure is Charity, part of a fourteenth-century sculptural group of the Virtues, who appears to pause in mid-step and peer into

Fratelli Alinari, *Pisa: Interior of the Camposanto*, 1862–63

Robert Macpherson, *Muro Torto, Rome*, 1871 or earlier, and detail

the shadows of the cloister. Behind her, the tomb of a sixteenth-century Pisan arch-bishop, Onofrio Bartolini de' Medici, is garlanded by the massive links of a girdle chain. The chain, though old, was a new arrival: stolen from Pisa's harbor by Genoa in 1342, it had been returned and put on view only in 1860. The Alinari, sons of a Florentine engraver of historic site views, seem to have inherited a knack for inani-mate stagecraft. Their image is a curated arrangement of history a few layers deep, in which the artful work of the Camposanto's conservator passes through a camera-man's interpretive hands. This is no sterile museum gallery but a theatrical pageant enacted by living pieces of the past and present.

Atop its historical body, however ancient or layered, every city wears a fast-growing, fast-peeling skin of Now: an outermost layer of time composed of hoardings, signage, fluttering laundry. As a focal point for pictorial attention, indirect traces such as these sometimes present a more evocative glimpse of history than scenes of social activity. Around 1870, Robert Macpherson, a specialist in large-format views of Rome, photographed the *muro torto*, a section of the Aurelian wall "twisted" (*torto*) since ancient times by shoring up the weight of the Pincian hill. Earlier artists had usually depicted the wall from off to one side, emphasizing its alarming tilt over the road. Macpherson instead views it from across the road, thereby revealing an adjacent section of wall that files picturesquely to the horizon, bathed in afternoon sunlight. By placing his camera so as to include that feature, Macpherson centered his view (inadvertently, it may be) on the center of the *muro torto*, home to a chalk drawing (see detail). The drawing, in effect, looks back at him: it portrays a gate that stood just to Macpherson's side, the so-called *Ingresso dal muro torto* (1790) that gave entry to the Borghese Gardens until it was chained shut in 1829. (The wing of a Borghese eagle, perched on one tower of the gate, is visible in the top left corner of the photograph.) The sketch is probably the work of an engineer or contractor plotting how to move the gate to another part of the gardens — a task pondered for generations and finally carried out in the 1930s, under Mussolini. In the ghostly form of the drawing, Macpherson's image records a half-formed intention that hovered for decades over this Roman corner.

If graffiti snuck past Macpherson's notice while he concentrated on photo-graphing more durable things, precisely the opposite is true of contemporary artist

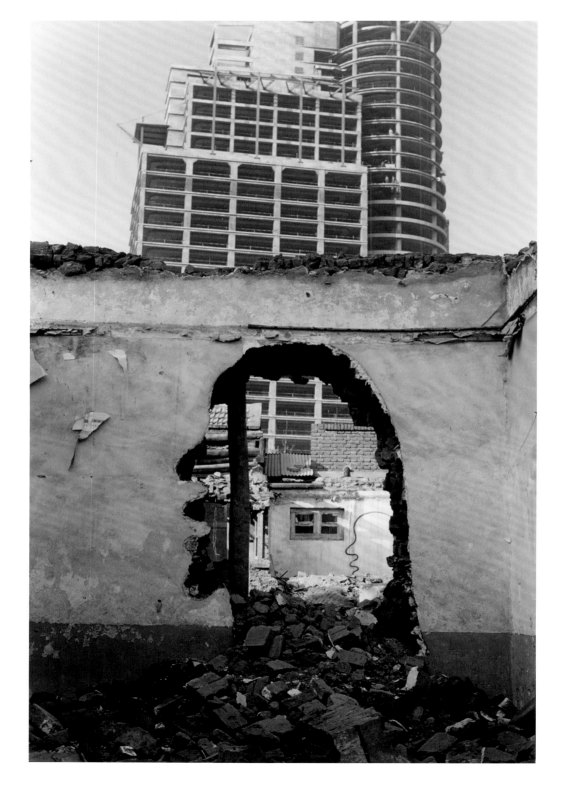

OPPOSITE
Zhang Dali, *Demolition—World Financial Center, Beijing*, 1998

RIGHT
John Szarkowski, *Corner Pier, The Prudential Building, Buffalo, New York*, 1951

Zhang Dali. In his *Dialogue and Demolition* project, begun during the Chinese boom years of the 1990s, Zhang worked in spray paint on buildings facing demolition in Beijing. After painting a signature human silhouette onto a wall, Zhang would hammer clean through it, creating an aperture that described the human void in a city that was, in his view, dying of money. Zhang stresses that he resorted to photography only in order to document the interventions, his first aim being "to communicate directly" with others in public spaces slated to disappear.

The Sentient Wall In the middle decades of the twentieth century, while a generation of American abstract artists worked to give their canvases the compellingly unfinished look of scarred city walls, the wall itself became ubiquitous in American art photography. Weathered, window-punctured, age-layered surfaces, scrutinized in full frontal detail and cropped free of all explanatory context, came to constitute

a distinct genre in the work of Aaron Siskind, Harry Callahan, Minor White, and many of their contemporaries. When presented in print or exhibition as "abstract photography," such images excused their "abstractness" by doubling as rigorously literal, straight representations of what an abstract painting is: an accumulation of markings on a flat upright plane. This half-apologetic version of abstraction, however, resuscitated an old question: was the art photograph just a poor man's painting, or did the camera bring something new to modern expression?

White addressed the issue in an essay titled "Peeled Paint, Cameras, & Happenstance" (1956). There was nothing "morbid," White claimed, in the photographer's attraction to "the weathered and worn." On the contrary, decay simply presented the best conditions for studying the lively action of chance; a timeworn wall is "a blackboard upon which happenstance does the writing." Artist photographers, White went on, recognize that "the older a building gets the further removed it is from the hand of the architect or builder....As age creeps on and chance takes over, the photographer can find things that were never intended by the originators....Finally the building is more like the photographer than the builder."

What White celebrated in the straight photograph was a more-than-factual rigor, one that found in visible facts themselves (and especially, in the age-altered human artifact) layers of ambiguity that called for poetic interpretation. Clarence John Laughlin, in a commentary glued to the mount of his photograph *The Masquerade*, insisted even more vehemently that imagination was an inseparable part of phenomenal appearances:

> Peeling wallpaper on the exposed wall of a dismantled house was the starting point for this picture. When we examine this print carefully, however, we begin to discover scores of fantastic and grotesque creatures — many of them masked, and all of them ghastly parodies of the human face and figure....Perhaps they suggest the kinds of things we become when hate and fear grip us....The picture has been dedicated to James Ensor — great Belgian master of the macabre; and painter of the disturbing, and revealing, masks that possess most men.

LEFT
Minor White, *Front Street,
Portland, Oregon*, 1939

RIGHT
Rudy Burckhardt, *Building
front detail*, 1938

54

TOP
Clarence John Laughlin,
The Masquerade, 1961

BOTTOM
Harry Callahan, *Chicago*,
ca. 1955

When adopted as a backdrop to human drama, the damaged wall reveals its humanistic symbolism all the more clearly. The ruined wall answers to many dramatic needs, from establishing a mood of pleasing vulnerability to hinting at violence so awful it can be represented only in symbolic disguise.

In the foreground of Philip Henry Delamotte's picturesque study of Fountains Abbey (1856) sits a man whose alert yet passive posture marks him as an elegist at work, absorbing the Romantic spirit of the ruined cloister. A century earlier, an influential commentator on garden follies had praised this kind of Gothic ruin, which embodies "the triumph of time over strength" ("a melancholy but not discouraging thought"), while judging that the classical ruin's more "gloomy and discouraging" lesson is "the triumph of barbarity over taste." Such poetic niceties seem far from the minds of the seven laconic bystanders who posed for James Wallace Black on Boston's Milk Street, a boundary of the great fire of November 1872. Facing them, behind Black and his camera, stood the half-built New Post Office, which had been spared — it would become the centerpiece of the rebuilt district — while sixty-five acres of warehouses, homes, and commercial buildings had burned. A still grimmer scene is the one recorded by Robert Capa during the Japanese bombardment of Hankow (Wuhan), China, in October 1938. Capa's subject is total devastation, in both the physical and the moral senses of the word: a woman with bound feet crouches, face in hands, on the threshold of a shattered house surrounded by malarial standing water.

But nothing sets the scene for redemption like the right kind of ruin, as Soviet photojournalist Dmitri Baltermants found in 1945 as he accompanied the Red Army in fallen Nazi Berlin. In a wrecked living room, Baltermants photographed five soldiers holding an impromptu recital around an upright piano. The image, dubbed *Tchaikovsky*, quickly became an iconic representation of the Soviet Union's hard-won victory over Hitler. With the graphic concision of a Norman Rockwell cover, Baltermants combines emblems of violent force, vivid yet bloodless — a ripped-open wall, a rubble-strewn room — with a Russian idyll of peacetime, in which young music lovers, weary of the labor of death, daydream about an imminent return to the motherland.

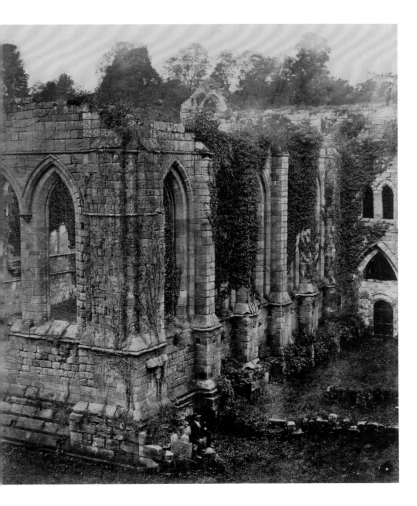

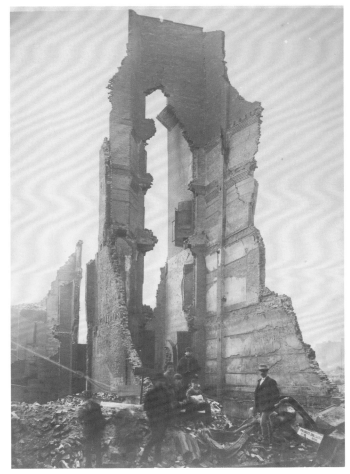

LEFT
Philip Henry Delamotte,
Fountains Abbey, Yorkshire, 1856

RIGHT
James Wallace Black, *67 Milk Street,*
The Boston Button Company—
Opposite the New Post Office, 1872

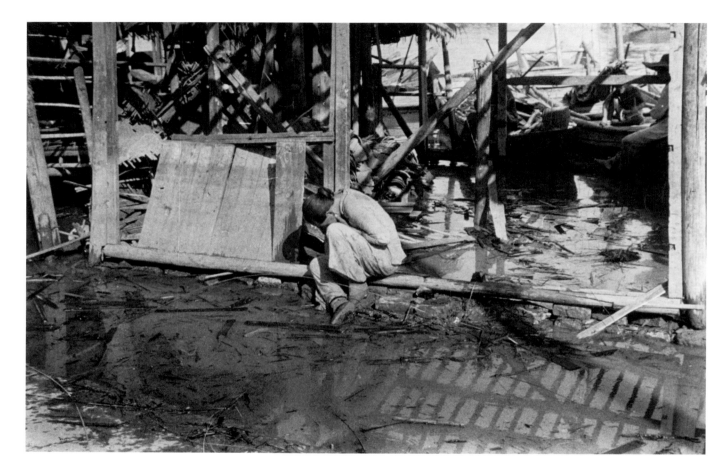

ABOVE
Robert Capa,
Hankow, China, 1938

OPPOSITE
Dmitri Baltermants,
Tchaikovsky, 1945

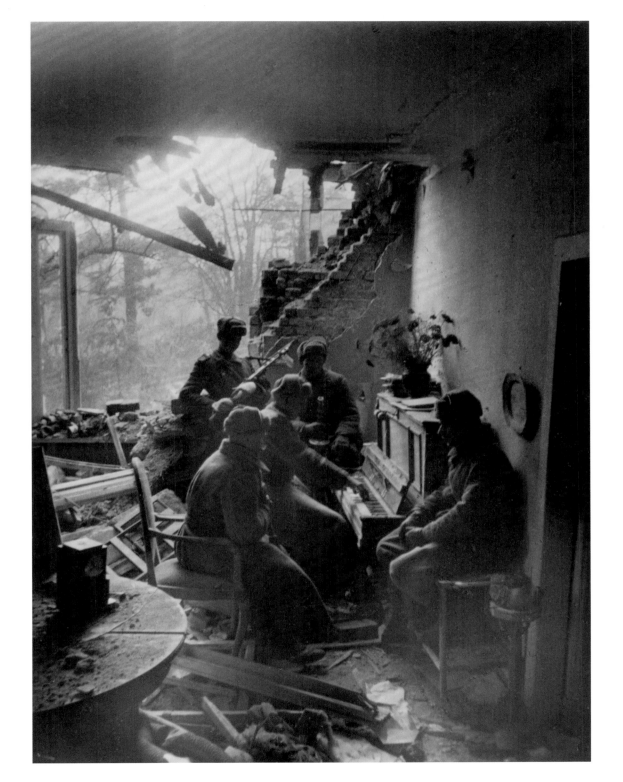

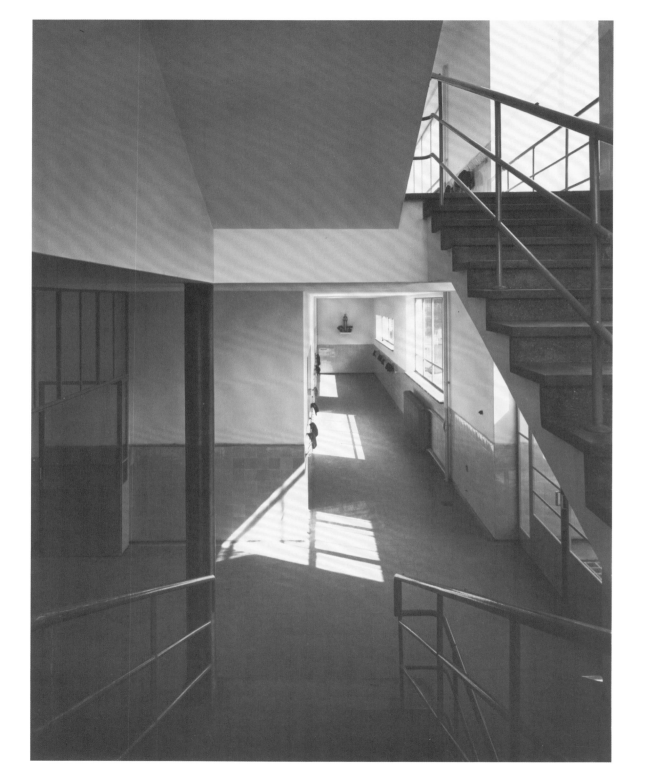

Paper Buildings Buildings are easily photographed inside or out. This is an unusual quality among camera subjects, and it describes what buildings do: they modulate space at the scale of the body. But photographs do not, cannot, neutrally translate space into two dimensions. The camera, as its name states, is a "chamber," a space annexed by the lens to any room it portrays. By its presence alone, the camera modifies the shape and proportions of the space around it. Its disembodied eye can reimagine a room as inventively and inhumanly as a cat. Placed in a corner, or in plane with a window, or at floor level (to name three very simple options), the camera generates pictorial spaces that entice the eye in part because they creatively expand on its range of experience. A pictorial format even more contrived, though today naturalized through long familiarity, is the bird's-eye view, a visual conceit that existed only in the speculative renderings of surveyor-draftsmen until 1858, when the first photographs from a balloon made it a reality.

When willfully eccentric perspective came into vogue in architectural photography of the 1920s and 1930s, critics disparaged the trend as "paper architecture." Among its other artful crimes, it made newfangled interiors look more spacious, comfortable, or well proportioned than they were. Modernist photographers exploited viewers' faith in the camera's honesty, creating images in which the latest articles of chic, such as the slab wall, punctuated pictorial space with a grace and drama they lacked in three dimensions. Werner Mantz's view of a new school hallway carves the scene into a sculptural relief of unearthly subtlety; straight-edged walls, ceilings, banisters, and floors take on second lives as pure form, intricately subdividing the picture plane into faceted tonal fields. Geometric, diagrammatic compositions such as this one have the ultimate effect of transplanting their subjects out of experiential time and into a utopian someday. Rather than saying "That-has-been" or even "This is," the most potent modernist photorenderings speak in a subjunctive voice resembling the religious prophet's "Would that this were."

In his photograph *Night in a Small Town* (1930), the German photojournalist Umbo (Otto Umbehr) combines overhead perspective with a prolonged exposure so that soft street lamps and moving headlights brightly encircle a sleeping city block. In this reassuring vision, electric power and the automobile appear not

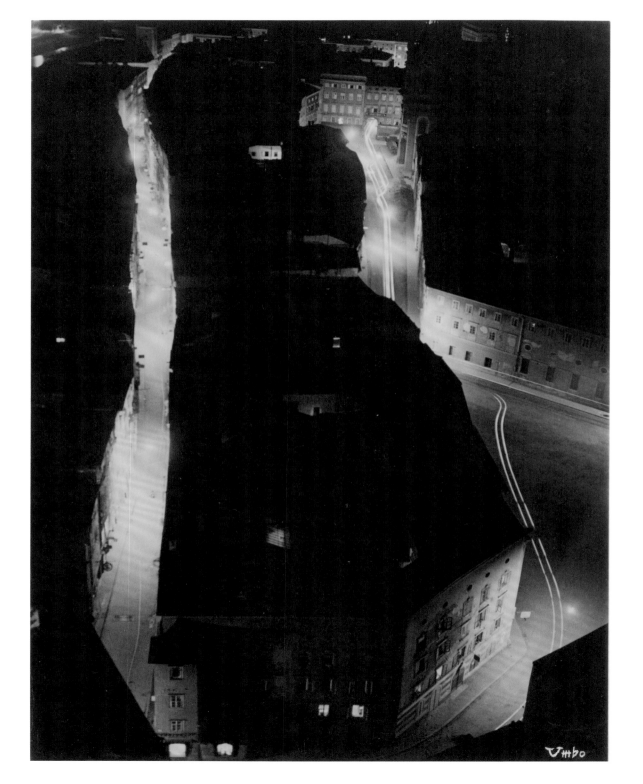

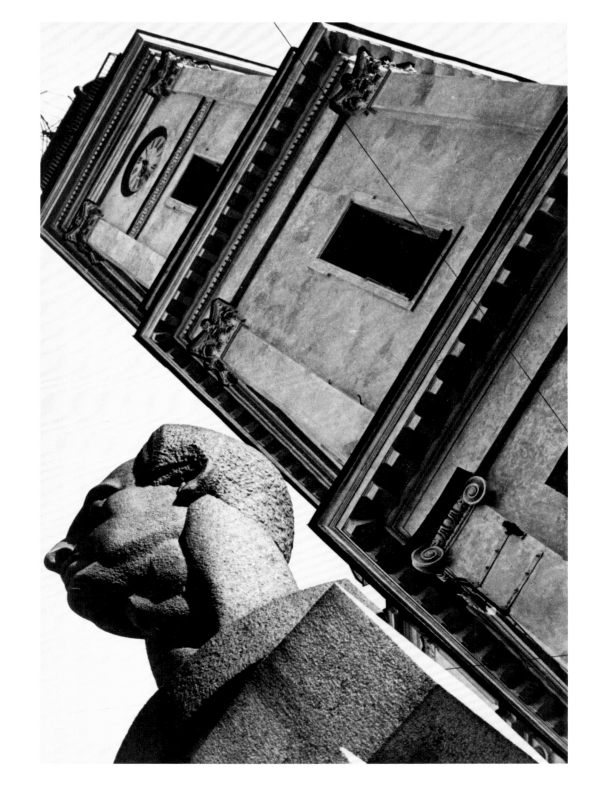

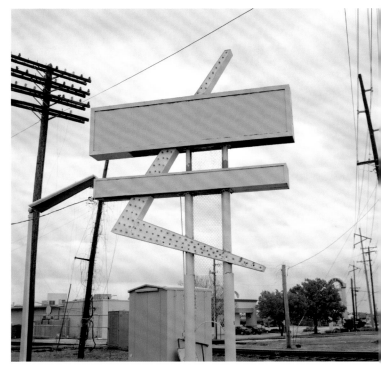

to threaten provincial peace but to hold it securely in place. In a more ambitious feat of historical legerdemain, Boris Ignatovich turns a premodern tower in Leningrad into modernist-architecture-by-proxy by marrying it, in a tightly cropped, upwardly angled worm's-eye view, to a sculptural monument to Ferdinand Lassalle (1825–1864), founder of the forerunner to Germany's Social Democratic Party. By invoking a chain of associations that unites Lassalle's integrity, the civic fabric of St. Petersburg, and upwardness, Ignatovich interprets Russia's prerevolutionary past as a prologue to its perfectible future under socialism.

Jeff Brouws's series *Signs without Signification* looks back at the heady modern century from its aftermath, an American landscape littered with relics of franchise capitalism. His portraits of shattered and disused roadside signs can be read as a typology, but it departs from the Bechers' model in notable ways. By focusing on the closing chapters in the lives of these unassuming structures, Brouws keeps them legibly grounded in history, their own and that of the economy that brought them into being. He discards the Bechers' formal language of objectivity, instead shooting glances up at the signs at angles that suggest the furtive gaze of a vagabond heading down the road with troubles of his own.

Time Frames Time's fluidity and momentum defy the capacities of the still photograph. Time never stops, and a photograph does nothing else. Even if that abstraction, "the moment," was not invented by the camera shutter (the "blink of an eye" surely preceded it), it is fair to say that, through its role in every field of endeavor from art to news to industrial efficiency studies, photography ratified the moment, codified it, and made it a standard unit for measuring the real. One simple means of expanding the temporal range of the photograph beyond the moment is to add more photographs — multiple frames, showing the subject changing through time. Sol LeWitt reduced this mechanism to its most basic form in a series of untitled diptychs showing a rough brick wall outside his studio window. In each pairing, the only real-world variable is the angle of sunlight raking the wall. By disclosing a static subject, the building, through an episodic medium, the photographic sequence, LeWitt turns bricks casting shadows into a momentous event.

Frame-as-time-parcel is literally the animating principle of cinema —
but when a film is running smoothly, its twenty-four frames per second are imper-
ceptible as such. The one medium truly composed of time frames is the comic
strip, in which narrative *happens* — is written and is read — in the form of images
in sequence. Like LeWitt with his diptychs, comic artist Richard McGuire exposes
the fundamentals of his medium by dismantling them. In the strip *Here* (1989),
McGuire centers our view squarely and fixedly upon one corner of a generic Ameri-
can living room. Each frame is a time parcel, labeled by year, but the frames jump
nonconsecutively through time, and as they do — 1957, 1922, 1971, 1940 — they
sprout subframes in which other bits of time inhabit the space with them. Perhaps
we are inside the mind of the place, the *genius loci* of this plot of land, which

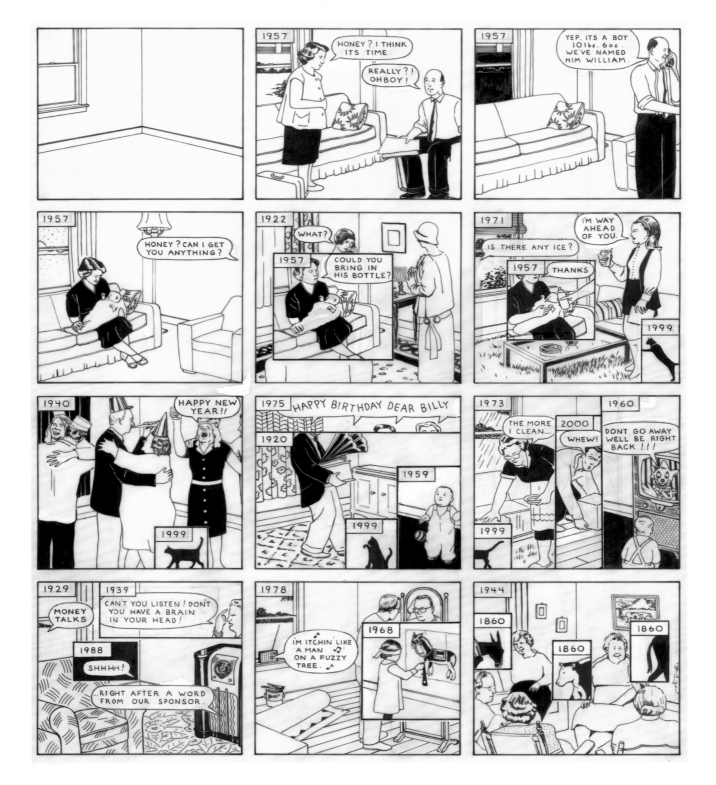

thinks in associations all its own, happily indifferent to matters of chronology and narrative. Thus in one frame a 1978 radio plays Elvis while a 1968 girl pins a tail on a donkey poster, and in the next an 1860 donkey stands at pasture, surrounded by a living-room party of 1944 housewives.

McGuire began *Here* with the idea of a movie-style split screen; the right side of each frame would tell the room's story from start to end, the left side in reverse. This literal adaptation of a cinema trick did not work, perhaps because it magnified the gap between the true simultaneity achievable on a movie screen and the inherent sequentiality of comic frames (as a reader, you must read one scene before the other). Light dawned when a friend told McGuire about the new Windows operating system, in which several computer files could be open on the screen at once. Here, he saw, was a time-neutral matrix, one in which frames stood in truly ambiguous sequential, causal, and conceptual relation to one another. Thus, the standpoint-free architecture of software, combined with a picture sequence based on a single standpoint, resulted in the quantum logic of the strip.

In photography, a comparably ambitious unwinding of time occurs in Masumi Hayashi's *Tule Lake Relocation Camp, Stockade*, a two-meter-wide photo-mosaic of drugstore-style color prints. Its 117 exposures were made with a tripod-mounted camera that Hayashi systematically rotated, up and down and side to side, to document her subject in a series of small details, like a Mars probe seeking signs of life. Tule Lake Segregation Center, in far northeastern California, was one of ten internment camps run by the War Relocation Authority after Japan's attack on Pearl Harbor in 1941. Americans of Japanese ancestry were incarcerated there by Executive Order 9066. Hayashi was born in another one of those camps, Gila River, in Arizona, in 1945, a month after the atomic bombing of Hiroshima and Nagasaki had secured Japan's surrender but several months before the residents of Gila River and Tule Lake were released. Forty-five years later, after Hayashi's father died, she undertook a personal survey of the camps that had shaped the lives of Japanese Americans of his generation and her own.

By the 1990s, when Hayashi was photographing the camps, they had weathered years of neglect, scavenging, and entropy. The subject of her composites is the relationship between time and attention: how history wishes away its least

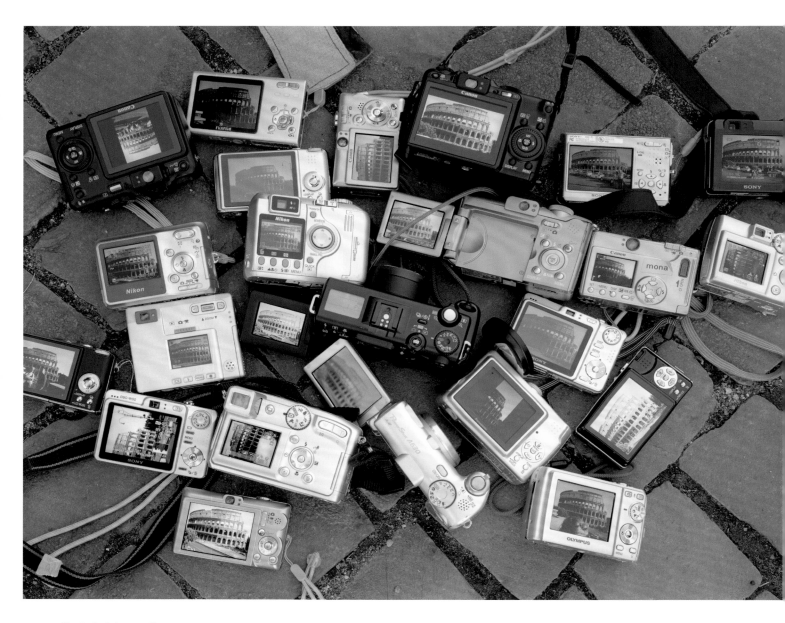

Tim Davis, *Colosseum Pictures*
(*The New Antiquity*), 2009

welcome chapters, and what it means to defy that willful ignorance and exercise scrutiny. Hayashi's composite studies reconcile three forms of time. Historical time, first, is legible in the state of the ruined stockade. Anecdotal or episodic time, the real time of experience, is measured in the course of Hayashi's successive shutter releases. And with the five 540-degree circuits of her camera, Hayashi invokes cyclical time, as the eye repeatedly returns to its original point of view, physically intact but altered by the just-completed exercise of consciousness.

The pictures cited in the title of Tim Davis's *Colosseum Pictures* (2009) are snapshots of the Colosseum, displayed on the screens of twenty-three point-and-shoot digital cameras. The cameras lie scattered facedown on a cobblestone surface, as if just confiscated from tourists by the Cliché Police. Such a force would have its work cut out for it. In digital times, the camera has become a portal between the worlds of the physical and the virtual. For the moment, these digital Colosseums have been safely contained within their host devices — but as batches of electronic information, they are subject at any moment to imminent release into the unchecked tide of globally connected data.

The Death of Buildings On the timescale of the living, where personal memories still attach to archived news accounts and where today's lingering regrets color last year's conflicts, September 11, 2001, unquestionably deserves the language of catastrophe. A little further out in time, where living memory gives out and documents take over the work of history, it grows difficult to assign coherent and useful meaning to the sites and artifacts of tragedy — a challenge well known to today's second-generation preservationists of Auschwitz and Hiroshima's Atom Bomb Dome.

Photography, at seventeen decades, is old enough to bear witness to a pattern that we, with our shorter lifespans, would rather not recognize as such. Civilizations spend years, or generations, erecting great buildings and cities, which are then obliterated, often at great loss of life and sometimes through human agency. This nation, in its short history, has seen little of that pattern. In the wake of the Civil War and of great fires in Chicago, San Francisco, Boston, and else-where, Americans have rebuilt, leaving their landscape few reminders, like those in

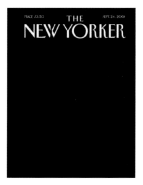

Art Spiegelman, *The New Yorker* cover, September 24, 2001

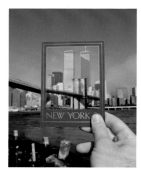

André Souroujon, *Wish You Were Here*, cover photograph for *The Village Voice*, September 18, 2001

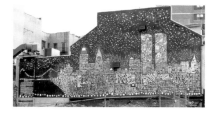

Hope Gangloff and City Arts, *Forever Tall* mural at Cooper Square, New York, 2001. © CITYarts, Inc. Forever Tall, 2001

the Old World, that the mighty fall. (Camilo José Vergara's 1995 proposal to declare twelve blocks of downtown Detroit a "skyscraper ruins park" was rejected by city boosters as little more than an empty ironic gesture.) It has been a privilege of Americans to believe in the permanence of their institutions and the structures that stand for them. But in New York City, within recent memory, experience caught up with the pattern.

As I write, the entry for "World Trade Center" on Wikipedia opens: "The World Trade Center (WTC) was a complex of seven buildings in Lower Manhattan in New York City that were destroyed in the September 11, 2001, terrorist attacks." Like the zeppelin Hindenburg (1936–37) or Jerusalem's Second Temple (516 B.C.E.–C.E. 70), the WTC appears fated to persist longer in the form of its memorialized annihilation than it did in life as a functioning structure.

Three thousand people died when four airliners were hijacked and crashed into the Pentagon, a field in south-central Pennsylvania, and the two highest towers of the World Trade Center. In print and broadcast coverage and in ad hoc memorials — murals, tattoos, t-shirts, window displays — the Twin Towers emerged instantly as emblems of the attacks. The inhuman massiveness of Minoru Yamasaki's design — a square plan drawn upright into a tall rectangle, twice — had made the towers instantly identifiable in presentation drawings and, once built, difficult to love. Their unhesitating rush upward lent the towers global currency as emblems of implacable American power, and that currency in turn helped focus the zealous enmity of their destroyers. Following the attacks, the gigantic, severe profile of the towers served still another function by making them effective vessels of mourning and memory. For as graphics, their undemonstrative profiles heightened the mood of stoic reticence that tempered the earliest, most emotional responses to the attacks, such as Art Spiegelman's black-on-black *New Yorker* cover, André Souroujon's *Wish You Were Here* cover photograph for the *Village Voice* (a view of lower Manhattan in which a handheld WTC postcard takes the place of the absent towers), and the skyline mural that went up at Cooper Square, in which the towers were rendered as flower-spangled rectangles.

Ten years later, it is difficult to remember or believe that camera phones did not figure in the spread of the news on that day. Within two years camera

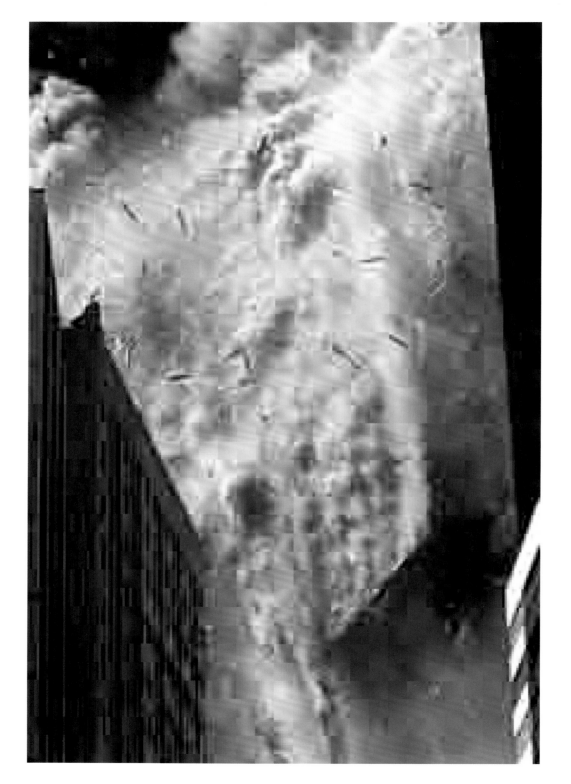

phones would account for the majority of digital cameras sold, and no disaster reportage would look complete without crowd-sourced footage, but on 9/11 no cell-phone camera was sending images from the floors above the fires or from the streets below. Indeed, the prevalent camera story of the day was about people racing into shops, tossing down cash for point-and-shoot film cameras, and racing off without waiting for change. Within two weeks a storefront had opened in Soho, where for $25 a print, for the benefit of the Children's Aid Society, one could order 11×14-inch laser printouts of 9/11-related photographs, submitted by anyone. In retrospect, it sounds almost inconceivably brick-and-mortar.

Thomas Ruff's *jpeg co01* depicts the moment that the North Tower collapsed, but visually it points to a later historical moment. The enormous prints in the *jpeg* series (*jpeg co01* is over two meters high) are enlargements derived from small image files culled from the Internet; their unifying feature is the distinctive pixelization pattern incurred in jpeg compression. The pixel is a signifier of transmission, of circulation as a photographic value. When rendered at this scale, the pixel doubles as a kind of brushstroke, mesmerizing and abstracting, and suggestive of the digital distances that separate sender from recipient, the historical moment from the moment of download. *Jpeg co01* is a harrowing image of the death of a building. At the same time it points to the death of buildings in a larger, more global sense, as location begins to mean less and linkage more. Electronic networks, by connecting correspondents across oceans while dividing people seated only a cubicle-partition or train-aisle apart, have usurped the building's old purpose of merging the lives of those under a shared roof.

A former student of Ruff's, Robert Voit, explores the on-the-ground reality of digital transmission in his photographic series *New Trees*, in which he portrays cell phone towers around the planet wearing variously cynical or convincing arboreal disguises. The touchstone for this typological series is, again, the Bechers (they were, in turn, Ruff's teachers), with Voit amending their formula by adding an aptly ambiguous note of sentimental beauty. Photographing in color, he works at times of day when sunlight paints a glow on the clouds overhead and on the rusting faux-bark of his subjects.

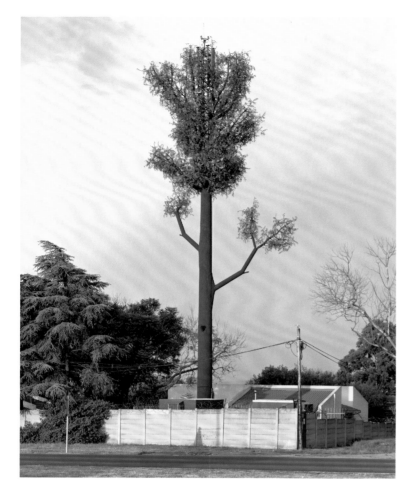

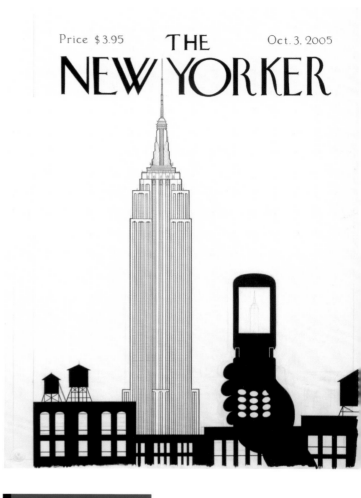

LEFT
Robert Voit, *Norscot, Sandton,
South Africa S26° 02.217 E028° 00.703*,
from the series *New Trees*, 2006

RIGHT
Chris Ware, *Hold Still*, cover
drawing (top) and finished cover
(bottom) for *The New Yorker*, 2005

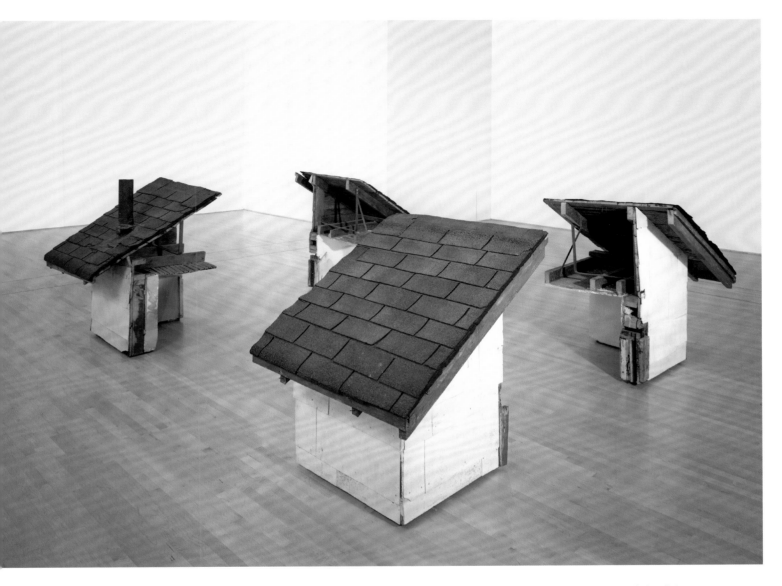

Gordon Matta-Clark, *Splitting: Four Corners*, 1974

What Does History Look Like? And where can it be seen? For a start, not in nature. The past as it can be read in nature — the density of a forest, the cycle of tides or seasons — describes time on no scale that helps lend sense to the human. The relative puniness of history comes across in displays of ancient tree rings in which the reign of Justinian, Mohammed's birth, and the rise of the Maya punctuate a narrow band midway between the core and the bark. History is time on the human scale, not the holy, cosmological, or natural. Finding our place in history, and a way into it, calls for a cultural version of the tree and its rings, one that will diagram our rootedness on the globe, link past to present, and measure the distance between them.

Ancient buildings, on this analogy, resemble uncut trees: they embody time, but mutely, and fixedly. You can wake up in a five-year-old suburban bedroom, head to the airport, and fly off to see an ancient temple half a world away, but the physical experience of all that distance underlines, rather than bridges, the temporal gap involved. Whether home or away, where you are remains difficult to reconcile with the reality you just left behind. What is needed (and what helps explain the enduring appeal of the still photograph today) is a prosthetic blink-of-the-eye, a you-are-there portal between the feeling of being in one pocket of time and in another.

Photographs succeed as evidence by persuading a viewer they are disinterested records. But even if only in the most literal sense, every photograph conveys a point of view, and any image of a site expresses an angle on its place in time. In 1844 photography's British inventor, William Henry Fox Talbot, photographed the so-called Bridge of Sighs at Cambridge in a way that emphasizes its graceful integration with the other buildings of St. John's College. With the prominence of a tree-ring tag, the date 1624 stands out in plate metal on a chimney overlooking the bridge. But Henry Hutchinson's bridge, as Talbot knew well, was a Neo-Gothic confection, built in 1831 and still an awkward teenager.

If a photograph can help wish away centuries, its acute eye can just as handily dispel the historical fictions of style. In Louis-Émile Durandelle's rooftop record of the pseudo-antique decorative sculptures for Charles Garnier's Opera House of Paris, one can nearly taste plaster dust and hear traffic on the boulevards below. A few years later, Durandelle ventured beneath another nearby landmark,

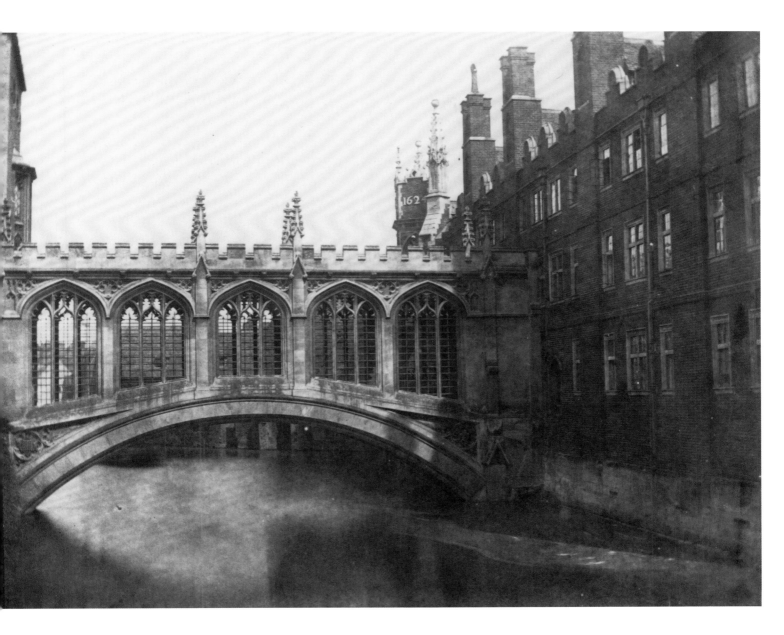

William Henry Fox Talbot,
*Bridge of Sighs, St. John's College,
Cambridge*, 1844

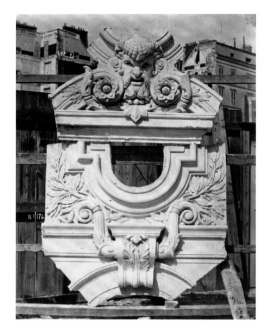

LEFT
Louis-Émile Durandelle, Model
of a decorative sculpture for the
New Paris Opera, ca. 1865

RIGHT
Louis-Émile Durandelle, Excavations
beneath the Louvre, 1882–84

OPPOSITE
Paul Berger, *Europe #2*, 1976

the sixteenth-century Louvre Palace, to document an archaeological exploration of remnants of the underlying twelfth-century castle. In the glare of a magnesium flash, Durandelle reveals a neatly carved space, demonstrating that the cyclical arts of building include the art of excavation, a subtractive craft. An archaeologist, like a construction engineer, breaks ground in order to convert raw-looking material into articulate structure and join it to the historical record.

Paul Berger's enigmatic *Europe #2* looks, at first glance, like a sectional view of an archaeological dig in stony ground, some centuries deep. On closer inspection, it reveals itself as an artifact of the darkroom. The two horizontal bands of lighter "sediment" were created by simple dodging, that is, covering a portion of the printing paper as it was exposed. This makes all the difference in how one reads the image — in particular, the amount of historical time and the type of historical agency it records. Berger began with an image of a fieldstone wall, built by a few people over a matter of days or weeks, and translated it into a shorthand representation of "history," a pile of the past that looks as if it were laid down gradually and unwittingly by everybody and by nobody in particular.

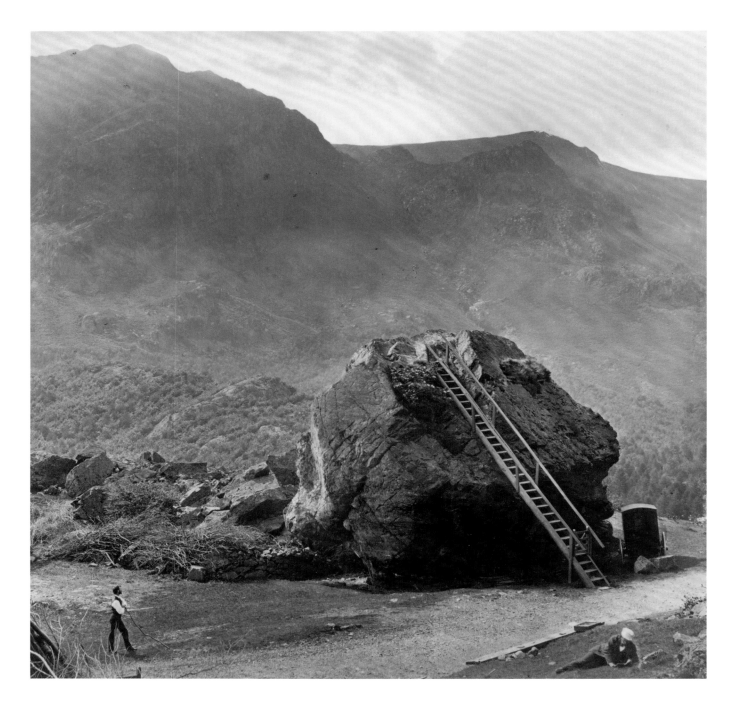

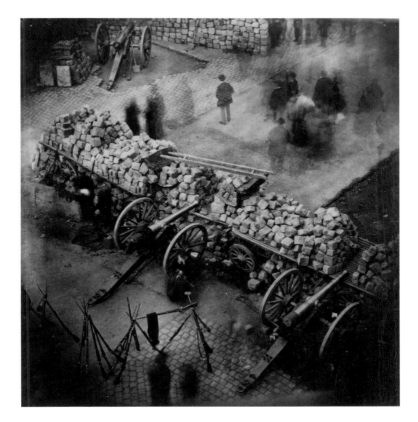

Specific history and anonymous history; anecdotal time and archaeo-
logical time. What kind of rocks you are looking at, and how they got laid down,
can matter. During the brief Paris Commune of spring 1871, Pierre-Ambrose
Richebourg made a haunting snapshot overlooking the street outside the Com-
munards' headquarters at the Hôtel de Ville. Running across the image is a
temporary structure: a barricade of cobblestones, pulled up from boulevards
recently widened by the state in order to accommodate the army, which indeed
would soon put down the Commune. Because Richebourg exposed for stone
rather than for human movement, his invaluable glimpse of history in action
simultaneously immortalizes the Communards and foresees their dismal fate:
at the height of their resistance, they are already ghosts.

Three Conclusions In the early 1930s the American photographer Alfred Stieglitz undertook a series of some ninety views of New York City. Stieglitz had secured his peerless reputation in art photography three decades earlier with his portrayals of street life in Manhattan, exposed using a handheld camera. Now, in what proved to be his valedictory series, he took big steps back, using a large view camera and photographing from the windows of his gallery and his apartment, both located high up in new high-rise towers. His 1931 twilight view northwest is characteristic of the series in its tonal lushness, in its minute attention to detail, and also in featuring skyscraper construction underway. The construction outside his windows preoccupied Stieglitz, and not in a good way. To survey the city of his youth from high above the streets felt like an adventure and like a form of exile; he felt that the city he had once known was literally disappearing from sight. "I have lived in this section of New York for fifty-four years," he told a friend, gesturing outside. "When we moved here, I a boy, it was all rocks and bare places. My father said it would one day become the center of New York.... Some day, I wonder if the last tree on Manhattan Island will not feel as I do. They have displaced trees with all that wonder — or so-called wonder." For Stieglitz — as for many before and after him — the emergence of a new city meant above all the loss of the old one, the one that was familiar to him, and for that reason immeasurably more real.

Just as Stieglitz was undertaking his high-rise views, Sigmund Freud, in Vienna, published *Civilization and Its Discontents* (1930), his late analysis of the intractable conflict between the individual's irrational desires and the imperatives of social order. Asserting that "in mental life nothing which has once been formed can perish," Freud opens his essay by proposing a simile that is (intentionally) impossible to visualize. He compares the modern mind, host to the innumerable primitive drives that once assured its survival, to a Rome in which all buildings from every phase of its past coexist, overlapping and unreconciled. Freud spins out the analogy for a page, then drops it. He drops it gladly, he says — first, because it really serves only to show "how far we are from mastering the characteristics of mental life by representing them in pictorial terms," and second, because it fails to recognize one of the great merits of a city: it rises and falls. Unlike the mind, hopelessly haunted by its past, even "the most peaceful development of a city," such

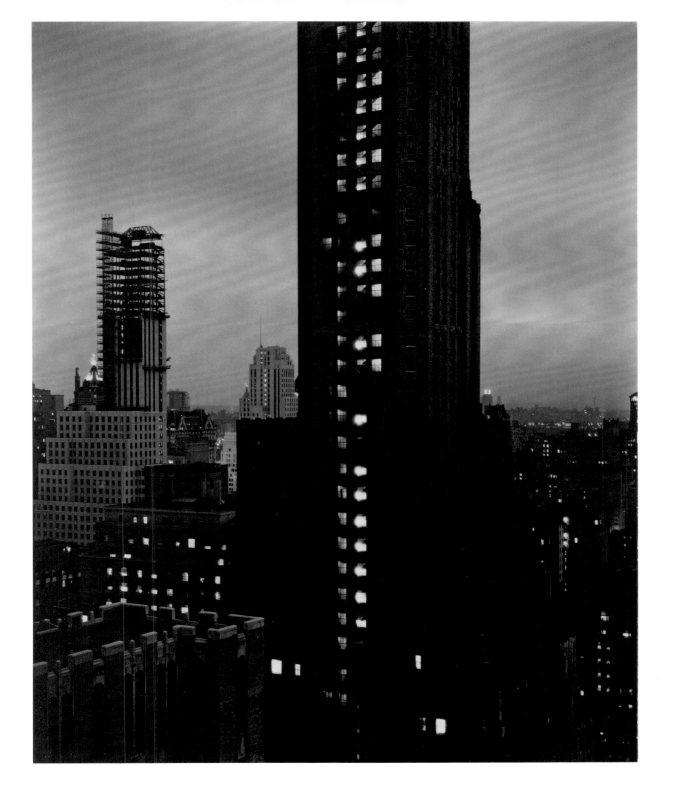

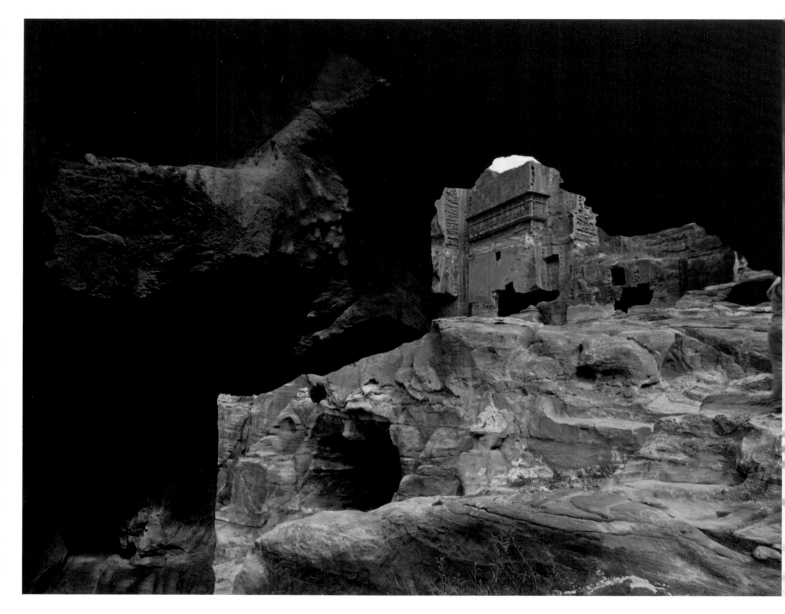

Emmet Gowin, *Tomb Fragments,*
the Outer Siq, Petra, Jordan, 1983

as London's, occurs through "demolitions and replacements of buildings." The psyche retains the shape of every force that formed it, but a city, to its great benefit, truly forgets. In demolitions — often painful, even violent — lie the city's salvation.

In 1983, standing inside a rock-hewn tomb at Petra, Jordan, Emmet Gowin created a picture that steps out of everyday time and onto the timescale of archaeology. In this disorienting image several visual ambiguities merge: What, here, is solid, and what is void? Where does space recede and form impend? Which of these shapes were carved by intention, which ones are artifacts of the camera's placement, and which have been worn by the wind? Instead of portraying ancient Petra as a city of the dead and the spot where he stands as a violated grave — natural perspectives for the living to assume — Gowin adopts the perspective of his subject, and looks around as if through an eye of stone. What he discloses is a view of history both deep and unsuffering. Imagine making a picture using film so insensitive to light (so "slow," in photographic parlance) that to burn an image onto it required an exposure of twenty-five centuries — geologically speaking, the blink of an eye. The picture from that negative would reveal a world made of stone and stone only: it would be a world where plants and people, seasons and civilizations, had come and gone too quickly to register; a world unlittered, unpainted, quite unbothered by mankind. And yet here it is, a world unmistakably shaped by human hands.

page 13 Buildings embody time: On buildings as manifestations of the past, see Christopher Woodward, *In Ruins* (New York: Pantheon Books, 2001); Alexander Stille, introduction and "The Sphinx—Virtual and Real," in *The Future of the Past* (New York: Farrar, Straus and Giroux, 2002), x–xxi, 3–31; and Christopher Woodward et al., *Visions of Ruin: Architectural Fantasies & Designs for Garden Follies* (London: Sir John Soane's Gallery, 1999).

page 13 Splitting: Gloria Moure, *Gordon Matta-Clark* (Madrid: Museo Nacional Centro de Arte Reina Sofía, 2006), 144–77. Matta-Clark resisted interpretations of his work that emphasized the abject state of its settings, saying: "The only reason I'm dealing with [condemned buildings] is because they're the ones that are available." Interview (1974) with Liza Bear in Moure, 172.

page 14 Burgos: The clock, installed by 1771, was gone by 1863. James Fergusson, *The Illustrated Handbook of Architecture* (London: J. Murray, 1855), illustrates the façade with the clock, but it is absent in a painting by F. Eibner dated 1863 in Jesús Urrea Fernández, *La Catedral de Burgos* (Madrid: Editorial Everest, 1982), 5.

Architecture and Buildings

page 16 Konstantinou: Many of Konstantinou's views for the Hellenic Archaeological Society are collected in the Department of Rare Books and Special Collections, Princeton University Library, Princeton, N.J., and the Benaki Museum, Athens. Thanks to Aliki Tsirgialu of the Benaki for help on questions of chronology.

page 16 falsification: On the mind's retention of familiar concatenations of fact, see Andrew Hollingworth, "Memory for Real-world Scenes," in *The Visual World in Memory*, ed. James R. Brockmole (New York: Routledge, 2009), 89–116.

page 18 Pavilion of Prince Teng: Wang Po, "Preface to Poems from the Pavilion of the Prince of T'eng," in Richard E. Strassberg, *Inscribed Landscape: Travel Writing from Imperial China* (Berkeley: University of California Press, 1994), 106–9.

page 19 Cleopatra's Needles: On the travels of these and other obelisks, see Brian A. Curran et al., *Obelisk: A History* (Cambridge, Mass.: MIT Press, 2009). W. W. Loring's *A Confederate Soldier in Egypt* (New York: Dodd, Mead, 1884) features a wood engraving after what is clearly a variant version of Beato's view.

page 23 "That-has-been": ("Ça-a-été") is the title of section 36 in Roland Barthes, *Camera Lucida: Reflections on Photography*, trans. Richard Howard (New York: Hill and Wang, 1981), 85–89, which ends: "From a phenomenological viewpoint, in the Photograph, the power of authentication exceeds the power of representation."

Time, Place, Detail

page 23 "anonymous sculptures": Bernhard Becher and Hilla Becher, *Anonyme Skulpturen: A Typology of Technical Constructions* (Düsseldorf: Art-Press, 1970).

page 24 "industrial landscapes": Bernd Becher and Hilla Becher, *Industrial Landscapes* (Cambridge, Mass.: MIT Press, 2002). The last active plant in Gelsenkirchen closed in the early 1990s. The rail line that once terminated at the Zeche Consolidation facility is today a regional walking trail, visible on Google Earth.

page 24 "integrated outcrops": Carolyn Dean, "The Inka Married the Earth: Integrated Outcrops and the Making of Place," *Art Bulletin* 89, no. 3 (September 2007): 502–18. Ranney's photograph appears in John Hemming and Edward Ranney, *Monuments of the Incas* (Boston: Little, Brown, 1982), 136.

page 26 Chichén Itzá: In a typed note glued to the mount verso of Princeton's print, Gilpin describes a return visit to Chichén Itzá in 1961. She showed her 1932 image to a guide who "said to me 'you made that picture on the 21st of March didn't you,'" and told her, for the first time, of the link between the balustrade shadow and the equinox. See also Andrew L. Slayman, "Seeing with Maya Eyes," *Archaeology* 49, no. 4 (July/August 1996) and Augusto Molina-Montes, "Archaeological Buildings: Restoration or Misrepresentation," in *Falsifications and Misreconstructions of Pre-Columbian Art*, ed. Elizabeth Hill Boone

(Washington, D.C.: Dumbarton Oaks, 1982), 125–40. Erik Boot, *Continuity and Change in Text and Image at Chichén Itzá, Yucatán, Mexico: A Study of the Inscriptions, Iconography, and Architecture at a Late Classic to Early Postclassic Maya Site* (Leiden: CNWS Publications, 2005), 250, concludes that the equinoctial effect was "designed and constructed with intention," and suggests that the number of triangles (seven) is symbolically "related to warfare." Thanks to Bryan Just for these references.

Houses

page 28 in the psyche…and in myth: See *The Surreal House*, ed. Jane Alison (New Haven, Conn.: Yale University Press, 2010).

page 28 homesteaders: On real-photo postcards and snapshots as documents of American popular history, see Hal Morgan and Andreas Brown, *Prairie Fires and Paper Moons: The American Photographic Postcard, 1900–1920* (Boston: David R. Godine, 1981) and Michael Williams et al., *Who We Were: A Snapshot History of America* (Chicago: CityFiles Press, 2008).

page 31 House of the Modern Age: Berenice Abbott and Elizabeth McCausland, *Changing New York* (New York: Federal Writers' Publications, 1939), pl. 64; "The All-Steel Home," *New York Times*, July 25, 1936, p. 12. The house, designed by Chrysler Building architect William Van Alen, funded by National Homes Inc., and outfitted by Modernage Furniture Corporation, was made of prefabricated steel panels covered in concrete. It was open to the public from late July to early October 1936.

page 33 Garnett: Most of the houses in the depicted section of the Silver Terrace neighborhood, bounded by Topeka, Thornton, Scotia, and Silver Avenues, were built in the early 1940s.

The Destruction of . . .

page 33 Lyon: Danny Lyon, *The Destruction of Lower Manhattan* (New York: Macmillan Company, 1969; 1st rev. ed., New York: powerHouse Books, 2005). See also Danny Lyon, *Knave of Hearts* (Santa Fe: Twin Palms, 1999), 38–44.

The Life of Buildings

page 41 Les Halles: One inscription in the negative and another on the mount of this print agree with Baldus's 1863 printed stock list in describing the subject of the image simply as "Église Saint-Eustache." The stock list is reproduced in Malcolm Daniel, *The Photographs of Édouard Baldus* (New York: Metropolitan Museum of Art, 1994), 231.

page 44 Moore: Andrew Moore, *Detroit Disassembled*, essay by Philip Levine (Akron, Ohio: Akron Art Museum and Damiani Editore, 2010).

page 46 "loaded with meaning": "Camouflage: An Interview with Lynne Cohen," in Ann Thomas, *No Man's Land: The Photography of Lynne Cohen* (London: Thames & Hudson, 2001), 29. In his account of a continual "collapsing" of authority in American culture since the 1920s, George W. S. Trow supplies a narrative parallel to Cohen's images of this period: "In any case, the buildings are the same: this one a sweet Victorian cottage, that one an old brick tenement out of Hopper; there, on the hill, is yet another new Tara, all columns and Cadillacs; the political parties have the same names; we still have a CBS, an NBC, and a *New York Times*; but we are not the same nation that had these things before." Trow, "Collapsing Dominant," new introduction to *Within the Context of No Context* (1981; 1st rev. ed., New York: Atlantic Monthly Press, 1997), 12–13.

page 46 Alinari: Artifacts in the image are identified in Cristiani Arias and Gabba Arias, *Camposanto monumentale di Pisa: Le antichità*, vol. 1, *Sarcofagi romani, iscrizioni romane e medioevali* (Pisa: Pacini Editore, 1977) and Clara Baracchini and Enrico Castelnuovo, *Il Camposanto di Pisa* (Turin: Giulio Einaudi, 1996).

page 49 *muro torto*: On the *muro torto* (or *storto*), the Aurelian Wall, and access to the Borghese Gardens, see Antonio Nibby and William Gell, *Le mura di Roma* (Rome: Vincenzo Poggioli Stampatore Camerale, 1820), 22–23; Ian A. Richmond, *The City Wall of Imperial Rome: An Account of Its Architectural Development from Aurelian to Narses* (Oxford: Clarendon Press, 1930), 13, pl. 11; and Alberta Campitelli, *Villa Borghese: Storia e gestione* (Milan: Skira, 2005). The number and title inscribed on Princeton's print echo Macpherson's December 1871 catalogue of views of Rome: "369. Muro Storto and the Barracks of the Praetorian Guard." A clerical error is indicated, since (as Macpherson could not but have known) these two landmarks lie too far apart to appear in one photograph. Piero Becchetti and Carlo Pietrangeli, *Robert Macpherson, un inglese fotografo a Roma* (Rome: Edizioni Quasar di Severino Tognon, 1987), 49–52.

page 51 "to communicate directly": Zhang Dali, "Artist Statement," in Wu Hung and Christopher Phillips, *Between Past and Future: New Photography and Video from China* (Chicago: Smart Museum of Art, University of Chicago and New York: International Center of Photography, 2004), 217.

The Sentient Wall

page 53 White essay: "Peeled Paint, Cameras & Happenstance," typescript dated April–May 1956, Minor White Archive, Princeton University Art Museum. Published as "Happenstance and how it involves the photographer," *Photography* (London), October 1956, 40–45, 73.

page 53 Laughlin: The caption on Princeton's print is a shorter draft of a text that accompanies multiple prints of the same image, retitled *The Masquerade of Fear and Hate*, in the Historic New Orleans Collection and Research Center, New Orleans, Louisiana. Laughlin ends the longer text by remarking that "in this picture, in 1961, I tried to convey a part of my intuitive reaction to the greed, the hidden violence, the climate of hate I felt in the atmosphere of Dallas in 1961, and even on earlier trips…. Uncannily enough, this picture was made only a few blocks away and on the same street, where on November 22, 1963, John F. Kennedy was assassinated."

page 56 Delamotte: Philip Henry Delamotte and Joseph Cundall, *A Photographic Tour among the Abbeys of Yorkshire* (London: Bell and Daldy, 1856).

page 56 commentator on garden follies: Henry Home [Lord Kames], in his *Elements of Criticism* (1762), cited in David Watkin, "Built Ruins: The Hermitage as a Retreat," in Woodward et al., *Visions of Ruin*, 8–9.

page 56 Black: The mount recto of Princeton's print is errantly inscribed in ink: "Pearl Street." Stephen Robert Edidin, *The Photographs of James Wallace Black: Views of the Ruins of the Great Fire in Boston, November, 1872* (Williamstown, Mass.: Williams College Museum of Art, 1977).

page 56 Capa: While awaiting the Japanese bombardment, Capa requested color film from his agency, Pix. Four of his images of the aftermath would become the first war photographs ever published in color, in the October 17, 1938, issue of *Life*.

page 56 Baltermants: Theodore H. Von Laue and Angela Von Laue, *Faces of a Nation: The Rise and Fall of the Soviet Union, 1917–1991* (Golden, Colo.: Fulcrum Publishing, 1996), 92.

Paper Buildings

page 61 "paper architecture": Robert Elwall, *Photography Takes Command: The Camera and British Architecture, 1890–1939* (London: RIBA Heinz Gallery, 1994), 61–96, and Robert Elwall, *Building with Light: The International History of Architectural Photography* (London: Merrell/RIBA 2004), 119–53.

Time Frames

page 65 LeWitt: George Stolz, "Clues from the Unknown: Sol LeWitt and Photography," in Stolz, *Sol LeWitt: Fotografía* (Madrid: La Fábrica Editorial, 2003), n.p.

page 66 McGuire: Thierry Smolderen, "An Interview with Richard McGuire," *Comic Art* 8 (2006), 23.

page 68 Hayashi: A full bibliography on the artist's work is maintained at www.masumimuseum.com.

page 71 Davis: The artist summarizes the photographs he made during a year of residence at the American Academy in Rome as "attempts to pour little molds of meaning for the peripheral present to harden in; to document a very real faux-archaeological significance as I tracked down ruined fragments of a very real ancient past." Tim Davis and Francine Prose, *The New Antiquity* (Bologna: Damiani, 2009), n.p.

The Death of Buildings

page 72 Vergara: Camilo José Vergara, *American Ruins* (New York: Monacelli Press, 1999).

page 75 cell-phone camera: In 2003, sales of stand-alone digital cameras leveled off and were surpassed by sales of cell-phone cameras, which have continued to increase at a rate of about 12 percent per year, reaching about one billion in 2009.

page 75 Ruff: Thomas Ruff and Bennett Simpson, *jpegs* (New York: Aperture, 2009).

page 75 Voit: Robert Voit and Christoph Schaden, *New Trees* (Göttingen: Steidl, 2011).

What Does History Look Like?

page 78 tree rings: Anthony Grafton and Daniel Rosenberg, in *Cartographies of Time: A History of the Timeline* (Princeton: Princeton Architectural Press, 2010), 21, describe dendrochronology and chronophotography as two outgrowths of a Positivist search, in the mid-nineteenth century, for "objective" metrics of time.

page 78 Talbot: The year 1624 is the date of the founding of St. John's library (Third Court), but the date appears on the chimney of the new library, completed in the year of Talbot's photograph. Larry J. Schaaf, *The Photographic Art of William Henry Fox Talbot* (Princeton: Princeton University Press, 2000), 215.

page 78 Durandelle: Bruno Foucart, *L'Opéra de Paris* (Paris: Centre National de la Photographie, 1985). Excavations beneath the Louvre between 1882 and 1884 were directed by Edmond Guillaume, a teacher of architectural theory at the École des Beaux Arts and architect at Versailles. Beatrice Bouvier, *L'Édition d'architecture à Paris au XIXe siècle: Les Maisons Bance et Morel et la presse architecturale* (Geneva: Librairie Droz, 2004), 108.

Three Conclusions

page 84 "I have lived…": Upon speaking these words, Stieglitz "pointed out of the window at twilit New York with its lighted towering buildings and roar of traffic." January 25, 1926, in Herbert J. Seligmann, *Alfred Stieglitz Talking: Notes on Some of His Conversations, 1925–1931* (New Haven: Yale University Library, 1966), 21. On Stieglitz's late work in New York, see Joel Smith, "New York Modernism and the Late Cityscapes of Alfred Stieglitz, 1927–1937" (Ph.D. diss., Princeton University, Department of Art and Archaeology, 2000).

page 84 Freud: Sigmund Freud, *Civilization and Its Discontents* (Vienna, 1930; New York: Norton, 1961), trans. James Strachey, 17–18.

page 87 Gowin: Emmet Gowin, *Petra: In the Hashemite Kingdom of Jordan* (New York: Pace/MacGill Gallery, 1986). Thanks to Jeff Evans for pointing out the human figure at extreme right in this image.

Sze Tsung Leong, *Jiangsheng Cun,*
Shanxi Province, from the series
History Images, 2004

All objects are in the collection
of the Princeton University
Art Museum except as noted.

Berenice Abbott, American, 1898–1991

House of the Modern Age, Park Avenue & 39th Street,
13 October 1936
Gelatin silver print
20 × 25.1 cm. (7 ⅞ × 9 ⅞ in.)
Gift of the Charina Foundation (2007-53)

West Street Row, between Warren and Murray Streets, 1936
Gelatin silver print
20 × 25.1 cm. (7 ⅞ × 9 ⅞ in.)
Gift of the Charina Foundation (2007-59)

City Arabesque, 1938, printed 1970s
Gelatin silver print
Image: 33.6 × 24.7 cm. (13 ¼ × 9 ¾ in.)
Mount: 50.8 × 40.6 cm. (20 × 16 in.)
Gift of Malcolm Goldstein, Class of 1947 (x1987-15)

Fratelli Alinari, active 1854–1920

Romualdo Alinari, Italian, 1830–1891
Leopoldo Alinari, Italian, 1832–1865
Giuseppe Alinari, Italian, 1836–1890

Pisa: Interior of the Camposanto, 1862–63
Albumen print
Image: 31.1 × 42.3 cm. (12 ¼ × 16 ⅝ in.)
Mount: 46.4 × 61.4 cm. (18 ¼ × 24 ⅛ in.)
Museum purchase, Fowler McCormick, Class of 1921,
Fund (2009-67)

Édouard Baldus, French, born in Prussia, 1813–1889

Église Saint-Eustache, 1855
Albumen print
Image: 42.5 × 33.6 cm. (16 ¾ × 13 ¼ in.)
Mount: 63.2 × 47.6 cm. (24 ⅞ × 18 ¾ in.)
Collection of Richard and Ronay Menschel

Dmitri Baltermants, Russian, 1912–1990

Tchaikovsky, 1945
Gelatin silver print
Image: 22.5 x 16.5 cm. (8 ⅞ × 6 ½ in.)
Sheet: 23.5 x 18 cm. (9 ¼ × 7 1/16 in.)
Museum purchase, Fowler McCormick, Class of 1921,
Fund (2010-77)

George N. Barnard, American, 1819–1902

Ruins of the Pinckney Mansion,
Charleston, South Carolina, 1866
Albumen print
Image: 25.5 × 35.8 cm. (10 1/16 × 14 ⅛ in.)
Mount: 41 × 51 cm. (16 ⅛ × 20 in.)
Museum purchase, David Hunter McAlpin, Class of 1920,
Fund (x1975-224)

The Ponder House, Atlanta, 1866
Albumen print
Image: 27.3 × 36.6 cm. (10 ¾ × 14 7/16 in.)
Mount: 40 × 51.4 cm. (16 × 20 ¼ in.)
Museum purchase, David Hunter McAlpin, Class of 1920,
Fund (x1975-234)

Antonio Beato, Italian and British, ca. 1825–ca. 1903

Cleopatra's Needle, Alexandria, 1860s
Albumen print in the album *Photographs of Egypt:*
Alexandria & Cairo
Image: 37.8 × 26.1 cm. (14 ⅞ × 10 ¼ in.)
Album: 40 × 53 cm. (15 ¾ × 20 ⅞ in.)
Museum purchase, David Hunter McAlpin, Class of 1920,
Fund (x1975-353)

Henri Béchard, French, active 1869–1890

Architectural view, Karnak, ca. 1875
Albumen print
Image: 26.8 × 37.6 cm. (10 9/16 × 14 13/16 in.)
Mount: 29.9 × 41.5 cm. (11 ¾ × 16 5/16 in.)
Museum purchase, anonymous gift (x1992-140)

Bernd Becher, German, 1931–2007
Hilla Becher, German, born 1934

Cooling Towers Wood-Steel, 1959–77
Nine gelatin silver prints
Image: 19.7 × 25.4 cm. (7 ¾ × 10 in.) each
Overall: 94.3 × 74 cm. (37 ⅛ × 29 ⅛ in.)
Museum purchase, anonymous gift (x1990-68 a–i)

Zeche Consolidation, Gelsenkirchen, Ruhr, Germany, 1974
Gelatin silver print
Edition 1/5
50.8 × 61 cm. (20 × 24 in.)
Museum purchase, Fowler McCormick, Class of 1921,
Fund (2010-124)

Francis Bedford, British, 1816–1894

Temple of Baalbek, 1862
Albumen print
Image: 20.5 × 26.6 cm. (8 1/16 × 10 1/2 in.)
Mount: 35.6 × 50.8 cm. (14 × 20 in.)
Gift of Mrs. Mary Ogden Thompson in memory of
Montgomery Kneass Ogden, Class of 1903,
and Bryan Kneass Ogden, Class of 1905 (x1984-99)

Enrico Béguin, French, active Rome

View of the Capitoline Hill, ca. 1850s
Albumenized salted paper print
Image: 15.6 × 11.6 cm. (6 1/8 × 4 9/16 in.)
Mount: 28.1 × 20.8 cm. (11 1/16 × 8 3/16 in.)
Anonymous loan

Paul Berger, American, born 1948
Europe #2, 1976, printed 1977
Gelatin silver print
Image: 35.9 × 21.5 cm. (14 1/8 × 8 7/16 in.)
Sheet: 50.5 × 40.6 cm. (19 7/8 × 16 in.)
Gift of Patricia and Franklin S. Kolodny (x1990-11)

Bisson Frères

Auguste-Rosalie Bisson, French, 1826–1900
Louis-Auguste Bisson, French, 1814–1876

*Leaf of the Door of Saint Marcel, Notre Dame
Cathedral*, ca. 1854
Albumen print
Image: 36.5 × 24.9 cm. (14 3/8 × 9 13/16 in.)
Mount: 55.1 × 35.8 cm. (21 11/16 × 14 1/8 in.)
Museum purchase, anonymous gift (1995-130)

James Wallace Black, American, 1825–1896

*67 Milk Street, The Boston Button Company—
Opposite the New Post Office*, 1872
Albumen print
Image (irregular): 43.2 × 30.7 cm. (17 × 12 1/16 in.)
Mount: 53.2 × 43.2 cm. (20 15/16 × 17 in.)
Museum purchase, anonymous gift (x1992-229)

Gabriel Blaise, French, active 1860–1880

Château de Langeais, ca. 1870
Albumen print
Image: 17 × 23.8 cm. (6 11/16 × 9 3/8 in.)
Mount: 30 × 43.5 cm. (11 13/16 × 17 1/8 in.)
Gift of Charles Isaacs and Carol Nigro (1997-450)

Studio of Adolphe Braun, French, 1811–1877

*Compagnie de l'Est, l'Ourche Viaduct,
Line from Jussey to Épinal*, ca. 1883–86
Carbon print
Image: 36 × 57 cm. (14 3/16 × 22 7/16 in.)
Mount: 42.2 × 64.1 cm. (16 5/8 × 25 1/4 in.)
Museum purchase, gift of David and Kathryn Richardson,
parents of Andrew Richardson, Class of 1992,
and Matthew Richardson, Class of 1997, in honor of
Peter C. Bunnell (2007-31)

Marilyn Bridges, American, born 1948

Radiating Lines, Nazca, Peru, 1979
Gelatin silver print
Image: 47.7 × 39.7 cm. (18 3/4 × 15 5/8 in.)
Sheet: 50.6 × 40.5 cm. (19 15/16 × 15 15/16 in.)
Gift of Fernando Vera, Class of 1979, and Marguerite Vera,
Class of 1979 (2000-428)

Jeff Brouws, American, born 1955

Signs without Signification portfolio, 2003–7
Pigment prints
17.8 × 17.8 cm. (7 × 7 in.) each
Edition 1/9
Museum purchase, Fowler McCormick, Class of 1921,
Fund (2007-91.1–.24)

Rudy Burckhardt, American, born in Switzerland,
1914–1999

Album page: building front details, New York City, 1938
Gelatin silver prints on recto and verso of album sheet
23.7 × 18.2 cm. (9 5/16 × 7 3/16 in.) (recto)
24 × 19 cm. (9 7/16 × 7 1/2 in.) (verso)
Lent by The Metropolitan Museum of Art. Purchase,
Florance Waterbury Bequest, 1972 (1972.585.4-.5)

Harry Callahan, American, 1912–1999

Chicago, ca. 1955
Dye transfer print
Image: 21.8 × 34.7 cm. (8 9/16 × 13 11/16 in.)
Sheet: 28.1 × 35.3 cm. (11 1/16 × 13 7/8 in.)
Gift of J. Michael Parish, Class of 1965 (x1991-258)

Robert Capa, American, 1913–1954

Hankow, China, 1938, printed later
Gelatin silver print
Image: 22.7 × 34.2 cm. (8 15/16 × 13 7/16 in.)
Sheet: 28.1 × 35.3 cm. (11 1/16 × 13 7/8 in.)
Gift of Howard Greenberg (1995-8)

Henri Cartier-Bresson, French, 1908–2004

Valencia, 1933, printed later
33.2 × 49.8 cm. (13 1/16 × 19 5/8 in.)
Gift of Elliott J. Berv, Portland, Maine (x1977-76)

Désiré Charnay, French, 1828–1915

Palace of the Nuns, Uxmal, 1857–61
Image: 33.6 × 42.6 cm. (13 1/4 × 16 3/4 in.)
Mount: 54 × 70.3 cm. (21 1/4 × 27 11/16 in.)
Museum purchase, bequest of John W. H. Simpson,
Class of 1966, in memory of Wellington Hope,
Class of 1931 (2001-209)

Louis de Clercq, French, 1836–1901

*Ninth Station of the Cross, Jerusalem: Jesus Falls for
the Third Time*, 1859–60
Albumen print
Image: 28.3 × 21.6 cm. (11 1/8 × 8 1/2 in.)
Mount: 58.2 × 45.5 cm. (22 15/16 × 17 15/16 in.)
Museum purchase, gift of Florence Gould Foundation
(2004-257)

Charles Clifford, British, ca. 1819–1863

Burgos Cathedral, Façade, 1853
Albumen print from waxed paper negative
Image: 41.9 × 30.5 cm. (16 1/2 × 12 in.)
Mount: 61.9 × 47 cm. (24 3/8 × 18 1/2 in.)
Museum purchase, Fowler McCormick, Class of 1921,
Fund (2010-125)

Lynne Cohen, Canadian, born in Racine, Wisconsin, 1944

Focus Scientific, Place Bell, Ottawa, Canada, 1976
Gelatin silver print
Image: 19 × 24.5 cm. (7 1/2 × 9 5/8 in.)
Mount: 38 × 38 cm. (14 15/16 × 14 15/16 in.)
Museum purchase, Fowler McCormick, Class of 1921,
Fund (2010-71)

Motel Room, 1979
Gelatin silver print
Image: 19 × 24.5 cm. (7 1/2 × 9 5/8 in.)
Mount: 38 × 38 cm. (14 15/16 × 14 15/16 in.)
Museum purchase, Fowler McCormick, Class of 1921,
Fund (2010-70)

Office and Showroom, 1980–81
Gelatin silver print
Image: 19 × 24.5 cm. (7 1/2 × 9 5/8 in.)
Mount: 38 × 38 cm. (14 15/16 × 14 15/16 in.)
Museum purchase, Fowler McCormick, Class of 1921,
Fund (2010-72)

Emergency Measures Auditorium, 1982
Gelatin silver print
Image: 19 × 24.5 cm. (7 1/2 × 9 5/8 in.)
Mount: 38 × 38 cm. (14 15/16 × 14 15/16 in.)
Museum purchase, Fowler McCormick, Class of 1921,
Fund (2010-75)

Louis-Jacques Mandé Daguerre, French, 1787–1851

Thiers, Auvergne, ca. 1827
Brush and watercolor wash over graphite underdrawing
on beige laid paper
17.4 × 27 cm. (6 7/8 × 10 5/8 in.)
Museum purchase, gift of Ehrich Galleries, by exchange
(x1988-141)

Tim Davis, American, born 1969

Colosseum Pictures (The New Antiquity), 2009
Chromogenic print
41.9 × 53.3 cm. (16 1/2 × 21 in.)
Museum purchase, gift of the Charina Foundation
(2009-130)

Philip Henry Delamotte, British, 1820–1889

The Upper Gallery, Crystal Palace, Sydenham, 1854
Albumen print
image: 27.5 × 23.2 cm. (10 ¹³⁄₁₆ × 9 ⅛ in.)
mount: 52.2 × 36.8 cm. (20 ⁹⁄₁₆ × 14 ½ in.)
Lent by The Metropolitan Museum of Art.
David Hunter McAlpin Fund, 1952 (52.639.34)

Fountains Abbey, plate 4 from the album
A Photographic Tour among the Abbeys of Yorkshire, 1856
Albumen print
Image: 28.4 × 23.5 cm. (11 ³⁄₁₆ × 9 ¼ in.)
Mount: 43.9 × 30.5 cm. (17 ¼ × 12 in.)
Museum purchase (x1986-25)

Robert Doisneau, French, 1912–1994

Graffiti, 1951
Gelatin silver print
36.7 × 30 cm. (14 ½ × 11 ¾ in.)
Museum purchase, gift of David and Kathryn Richardson,
parents of Andrew Richardson, Class of 1992,
and Matthew Richardson, Class of 1997, in honor of
Peter C. Bunnell (2011-28)

Jules Duclos, French, active 1860s

*Line from Châteaulin to Landerneau: Daoulas Viaduct.
Construction of Piers*, ca. 1860s
Albumen print
Image: 33.7 × 25.2 cm. (13 ¼ × 9 ¹⁵⁄₁₆ in.)
Mount: 56 × 45.8 cm. (22 ¹⁄₁₆ × 18 ¹⁄₁₆ in.)
Gift of Charles Isaacs and Robert Hershkowitz (1997-449)

Louis-Émile Durandelle, French, 1839–1917

Model of a decorative sculpture for the New Paris Opera,
ca. 1865
Albumen print
Image: 27.8 × 21.1 cm. (10 ¹⁵⁄₁₆ × 8 ⁵⁄₁₆ in.)
Mount: 60.4 × 44.5 cm. (23 ¾ × 17 ½ in.)
Museum purchase, gift of the Florence Gould Foundation
(x1994-49)

Excavations beneath the Louvre, 1882–84
Albumen print
Image: 34.5 × 43.9 cm. (13 ⁹⁄₁₆ × 17 ⁵⁄₁₆ in.)
Sheet: 62.6 × 47.8 cm. (24 ⅝ × 18 ¹³⁄₁₆ in.)
Museum purchase, Fowler McCormick, Class of 1921,
Fund (2009-66)

Frederick H. Evans, British, 1853–1943

*Westminster Abbey, Chapel of Henry VII,
Looking East*, ca. 1911
Platinum print
Image: 21.6 × 18.7 cm. (8 ½ × 7 ⅜ in.)
Mount: 24.4 × 20.5 cm. (9 ⅝ × 8 ¹⁄₁₆ in.)
Museum purchase, anonymous gift (x1990-64)

Julian Faulhaber, German, born 1975

Ceiling, 2006
Lambda print mounted on DiBold
Edition 4/7
152.4 × 119.4 cm. (60 × 47 in.)
Promised gift of Philip F. Maritz, Class of 1983

Frith Series, British

York, Railway Station, after 1877
Albumen print
Image: 19.1 × 29 cm. (7 ½ × 11 ⅜ in.)
Mount: 26 × 36.1 cm. (10 ¼ × 14 ¼ in.)
Museum purchase, anonymous gift (2008-63)

William A. Garnett, American, 1916–2006

Housing Development, San Francisco, California, 1953–56
Gelatin silver print
39.6 × 49.5 cm. (15 ⁹⁄₁₆ × 19 ½ in.)
Gift of David H. McAlpin, Class of 1920 (x1971-261)

Laura Gilpin, American, 1891–1979

Stairway, Temple of Kukulcán, Chichén Itzá, Yucatán, 1932,
printed later
Image: 34 × 27.1 cm. (13 ⅜ × 10 ¹¹⁄₁₆ in.)
Mount: 45.7 × 36 cm. (18 × 14 ⅛ in.)
Gift of Mr. W. Howard Adams (x1971-23)

Emmet Gowin, American, born 1941

Tomb Fragments, the Outer Siq, Petra, Jordan, 1983,
printed 1985
Toned gelatin silver print
Image: 19 × 24.1 cm. (7 ½ × 9 ½ in.)
Sheet: 26.6 × 35.2 cm. (10 ½ × 13 ⅞ in.)
Collection of Richard and Ronay Menschel

Masumi Hayashi, American, 1945–2006

Tule Lake Relocation Camp, Stockade, 1992
Photomosaic of chromogenic prints
54.8 × 190.8 cm. (21 ⁹⁄₁₆ × 75 ⅛ in.)
Museum purchase, anonymous gift in honor of
Peter C. Bunnell (2003-256)

Lewis W. Hine, American, 1874–1940

Laying a Great Beam on the Empire State Building, 1930
Gelatin silver print
Image: 34.3 × 24.6 cm. (13 ½ × 9 ¹¹/₁₆ in.)
Sheet: 35.4 × 27.8 cm. (14 × 11 in.)
Anonymous gift (x1973-41)

Peter Hujar, American, 1934–1987

Canyon, with Americana Hotel, 1976
Gelatin silver print
Image: 37.5 × 37.2 cm. (14 ¾ × 14 ⅝ inches)
Sheet: 50.5 × 40.5 cm. (19 ⅞ × 16 inches)
Gift of Stephen Koch (2005-249)

The World Trade Center, Twilight, 1976
Gelatin silver print
Image: 37.5 × 37.5 cm. (14 ¾ × 14 ¾ in.)
Sheet: 50.5 × 40.3 cm. cm. (19 ⅞ × 15 ⅞ in.)
Collection of Richard and Ronay Menschel

Boris Ignatovich, Russian, 1899–1976

Monument to Ferdinand Lassalle, Leningrad, 1930
Gelatin silver print
28.8 × 19.6 cm. (11 ⅜ × 7 ¾ in.)
Collection of Richard and Ronay Menschel

J. Payne Jennings, British, active ca. 1875–1926

Barrowdale — Bowder Stone, ca. 1890
Albumen print
21 × 27.3 cm. (8 ¼ × 10 ¾ in.)
Gift of Douglas Hahn, Class of 1934 (x1976-163)

Kikuji Kawada, Japanese, born 1933

Ceiling, Atomic Bomb Memorial Dome,
from the series *The Map*, 1960–65, printed 1973
Gelatin silver print
Image: 17 × 27.9 cm. (6 ¹¹/₁₆ × 11 in.)
Sheet: 30.3 × 37.9 cm. (11 ¹⁵/₁₆ × 14 ¹⁵/₁₆ in.)
Gift of Robert Gambee, Class of 1964 (x1985-88)

Peter Keetman, German, 1916-1987

Baustelle (Building Site), 1954
Gelatin silver print
30.1 × 23.4 cm. (11 ⅞ × 9 ³/₁₆ in.)
Lent by The Metropolitan Museum of Art. Purchase,
The Horace W. Goldsmith Foundation Gift, through
Joyce and Robert Menschel, 1992 (1992.5046)

Dimitris Konstantinou, Greek, died 1875

Temple of Olympian Zeus, Athens, 1858
Albumen print
Image: 28.3 × 38.4 cm. (11 ⅛ × 15 ⅛ in.)
Mount: 37.6 × 47.8 cm. (14 ¾ × 18 ⅞ in.)
Museum purchase, Fowler McCormick, Class of 1921,
Fund (2010-25)

Temple of Olympian Zeus, 1858, printed 1875 or later by
Konstantinos Athanasiou
Albumen print
Image: 27.9 × 37.8 cm. (11 × 14 ⅞ in.)
Mount: 36 × 55.5 cm. (14 ⅛ × 21 ⅞ in.)
Museum purchase, Fowler McCormick, Class of 1921,
Fund (2010-26)

Studio of G. R. Lambert, active Singapore, 1875–1919

Staircase to Wat Cheng, ca. 1895
Albumen print
27.5 × 20.8 cm. (10 ¹³/₁₆ × 8 ³/₁₆ in.)
Gift of Mrs. George Packer Berry in honor of her
husband, Class of 1921 and Charter Trustee of Princeton
University, 1956–1969 (2008-1059)

Clarence John Laughlin, American, 1905–1985

The Masquerade, 1961
Gelatin silver print
Image: 27.9 × 34.9 cm. (11 × 13 ¾ in.)
Mount: 35.5 × 43.1 cm. (14 × 17 in.)
Gift of Howard and Katia Read (x1993-179)

Sze Tsung Leong, American and British, born 1970

Jiangsheng Cun, Shanxi Province,
from the series *History Images*, 2004
Chromogenic print
Edition 9/10
101.6 × 121.9 cm. (40 × 48 in.)
Gift of David Solo (2010-222)

Sol LeWitt, American, 1928–2007

Untitled, 1977, printed 1995
Two gelatin silver prints
Overall: 27.2 × 43.1 cm. (10 ¹¹/₁₆ × 16 ¹⁵/₁₆ in.)
Mount: 51 × 66 cm. (20 ¹/₁₆ × 26 in.)
Museum purchase, bequest of John W. H. Simpson,
Class of 1966, in memory of Wellington Hope Simpson,
Class of 1931 (1995-292)

Danny Lyon, American, born 1942

Images from *The Destruction of Lower Manhattan*, 1967
Portfolio of 72 gelatin silver prints
Printed in 2007 by Chuck Kelton
Sheets: 43.2 × 35.6 cm. (17 × 14 in.) or the reverse
Gift of M. Robin Krasny, Class of 1973 (2009-150.1–.72)

Lower Manhattan
25.3 × 25 cm. (10 × 9 ⅞ in.)
(2009-150.1)

80 and 82 Beekman Street
25.1 × 24.8 cm. (9 ⅞ × 9 ¾ in.)
(2009-150.3)

The view south on Cliff Street at its intersection with Beekman
25.2 × 25.1 cm. (10 × 9 ⅞ in.)
(2009-150.6)

View from a Gold Street rooftop looking east toward the rear of Fulton Street
25.2 × 25 cm. (10 × 9 ⅞ in.)
(2009-150.8)

The west side of Gold Street between Ann and Beekman Streets
24.2 × 31.5 cm. (9 ½ × 12 ⅜ in.)
(2009-150.9)

327, 329, and 331 Washington Street, between Jay and Harrison Streets
23.6 × 30 cm. (9 ⅜ × 11 ⅞ in.)
(2009-150.18)

West Street at Warren
23.4 × 29.8 cm. (9 ¼ × 11 ¾ in.)
(2009-150.24)

174 Chambers Street at Bishop's Lane
29.8 × 23.5 cm. (11 ¾ × 9 ¼ in.)
(2009-150.25)

Susquehanna Hotel. Self-portrait in a third-floor room with grass
25.2 × 24.9 cm. (10 × 9 ¾ in.)
(2009-150.40)

View south from 100 Gold Street
25.2 × 25.2 cm. (10 × 10 in.)
(2009-150.43)

Staircase, 183 William Street
25.1 × 25 cm. (9 ⅞ × 9 ⅞ in.)
(2009-150.45)

Demolition men's headquarters, 38 Ferry Street
31 × 24.5 cm. (12 ¼ × 9 ⅝ in.)
(2009-150.55)

Dropping a wall
31 × 20.8 cm. (12 ¼ × 8 ⅛ in.)
(2009-150.60)

The St. George Building
23.3 × 30 cm. (9 ¼ × 11 ⅞ in.)
(2009-150.64)

A week later. Women search for the Beekman Hospital
23.4 × 29.5 cm. (9 ¼ × 11 ⅝ in.)
(2009-150.65)

Beekman Street subbasement. The demolition contract requires that the building be brought down to street level. Basements and tunnels are filled in and left buried beneath vacant lots
31 × 20.7 cm. (12 ¼ × 8 in.)
(2009-150.67)

View through the rear wall, 89 Beekman Street
25.2 × 24.9 cm. (10 × 9 ¾ in.)
(2009-150.70)

The ruins of 100 Gold Street
25.2 × 24.8 cm. (10 × 9 ¾ in.)
(2009-150.72)

Robert Macpherson, British, 1811–1872

Muro Torto, Rome, 1871 or earlier
Albumen print
Image: 23.3 × 47.5 cm. (9 3/16 × 18 11/16 in.)
Mount: 47.9 × 58 cm. (18 ⅞ × 22 ⅞ in.)
Museum purchase, David H. McAlpin, Class of 1920, Fund (x1975-100)

Werner Mantz, German, 1901–1983

School Interior: View from Stairway and Hall, 1932
Gelatin silver print
22.4 × 16.9 cm. (8 × 6 ⅝ in.)
Lent by The Metropolitan Museum of Art. Ford Motor Company Collection, gift of Ford Motor Company and John C. Waddell, 1987 (1987.1100.138)

Gordon Matta-Clark, American, 1943–1978

Splitting: Four Corners, 1974
Installation of building fragments; dimensions variable
Lent by San Francisco Museum of Modern Art. Purchase
through a gift of Phyllis Wattis, the Art Supporting
Foundation to the San Francisco Museum of Modern Art,
the Shirley Ross Davis Fund, and the Accessions
Committee Fund: gift of Mimi and Peter Haas, Niko and
Steve Mayer, Christine and Michael Murray, Helen and
Charles Schwab, Norah and Norman Stone, and Danielle
and Brooks Walker Jr. (2001.303.A-D)

Roger Mayne, British, born 1929

Wall Detail
Gelatin silver print
27.2 × 23.3 cm. (10 11/16 × 9 3/16 in.)
Museum purchase with funds given by the Geraldine R.
Dodge Foundation (x1986-98)

Richard McGuire, American, born 1957

Here, 1989
Pen and mixed media on three sheets of paper
43.1 × 35.5 cm. (17 × 14 in.) each
Collection of Richard McGuire

Richard Misrach, American, born 1949

White Man Contemplating Pyramids, 1989
Chromogenic print
Edition 1/25
Image: 47 × 59.5 cm. (18 1/2 × 23 in.)
Sheet: 50.8 × 61 cm. (20 × 24 in.)
Gift of Paul Runyon, by exchange, and the artist (2011-2)

Andrew Moore, American, born 1957

Model T Headquarters, Highland Park,
from the series *Detroit*, 2009
Digital inkjet print
Edition 1/5
Image: 91.4 × 115.6 cm. (36 × 4 1/2 in.)
Sheet: 115.6 × 138.4 cm. (45 1/2 × 54 1/2 in.)
Gift of the artist, Class of 1979, in honor of Emmet Gowin
(2009-115)

M. J. Pollack, American, active 1940

Features of Buildings, Brooklyn, 1946–48
Staircase and landing from above; Staircase with
missing banister rails; Doorjamb
Three gelatin silver prints
30.5 × 15.2 cm. (12 × 6 in.) each
Museum purchase, Fowler McCormick, Class of 1921,
Fund (2010-10.2, 2010-10.6, 2010-10.7)

Carlo Ponti, Italian, ca. 1828–1900

Doge's Palace, Venice, ca. 1865
Albumen print
Image: 33.5 × 24.7 cm. (13 3/16 × 9 3/4 in.)
Mount: 44 × 30.5 cm. (17 3/8 × 12 in.)
Museum purchase, gift of Mr. and Mrs. Max Adler
(x1984-208)

Egyptian Columns, St. Mark's Basilica, Venice, ca. 1865
Albumen print
Image: 34.1 × 24.7 cm. (13 7/16 × 9 3/4 in.)
Mount: 44 × 31 cm. (17 3/8 × 12 1/4 in.)
Museum purchase, gift of Mr. and Mrs. Max Adler
(x1984-210)

Edward Ranney, American, born 1942

Machu Picchu (Cave, Torreón Complex), 1975
Gelatin silver print
Image: 32.4 × 46.3 cm. (12 3/4 × 18 1/8 in.)
Sheet: 40.6 × 50.8 cm. (16 × 20 in.)
Gift of John B. Elliott, Class of 1951 (2000-172)

Pampa de San José, Nazca, 1985
Gelatin silver print
Image: 32.7 × 47.6 cm. (12 7/8 × 18 5/8 in.)
Sheet: 38 × 49.7 cm. (15 × 19 5/8 in.)
Gift of John B. Elliott, Class of 1951 (2000-215)

Pierre-Ambrose Richebourg, French, ca. 1810–ca. 1876

*Barricades of the Commune, April 1871. Corner of the
place Hôtel de Ville and the rue de Rivoli*, 1871
Albumen print
10.6 × 10 cm. (4 3/16 × 3 15/16 in.)
Lent by The Metropolitan Museum of Art. Purchase,
The Horace W. Goldsmith Foundation Gift, through
Joyce and Robert Menschel, 1998 (1998.334.1)

Alexander Rodchenko, Russian, 1891–1956

White Sea Canal, 1933, printed later
Gelatin silver print
Image: 16.5 × 23.8 cm. (6 ½ × 9 ⅜ in.)
Sheet: 17.7 × 23.8 cm. (7 × 9 ⅜ in.)
Collection of Richard and Ronay Menschel

Thomas Ruff, German, born 1958

jpeg co01, 2004
Chromogenic print
Edition 2/3
267.3 × 184.7 × 6 cm. (105 × 72 ¾ × 2 ⅜ in.) (framed)
Private collection

Edward Ruscha, American, born 1937

Every Building on the Sunset Strip, 1966
Paperback book in offset lithography
(closed) 18 × 14.4 cm. (7 ¹/₁₆ × 5 ¹¹/₁₆ in.)
Museum purchase, gift of Alexander D. Stuart,
Class of 1972 (1997-90)

Aaron Siskind, American, 1903–1991

Chicago 13, 1952, printed later
Gelatin silver print
Image: 25.6 × 32.8 cm. (10 ¹/₁₆ × 12 ¹⁵/₁₆ in.)
Sheet: 28 × 35.5 cm. (11 × 14 in.)
Gift of Dr. Bernard Barrish (x1984-149)

Frederick Sommer, American, born in Italy, 1905–1999

Max Ernst, 1946
Toned gelatin silver print
Image: 19.3 × 24 cm. (7 ⅝ × 9 ⁷/₁₆ in.)
Sheet: 26.7 × 32 cm. (10 ½ × 12 ⅝ in.)
Anonymous gift (x1985-44)

Alfred Stieglitz, American, 1864–1946

From My Window at the Shelton, North, 1931
Gelatin silver print
Image: 24.2 × 19 cm. (9 ½ × 7 ½ in.)
Mount: 58 × 45.9 cm. (22 ⅞ × 18 in.)
Gift of Ansel Adams in honor of David Hunter McAlpin,
Class of 1920 (x1974-36)

John Szarkowski, American, 1925–2007

Corner Pier, The Prudential Building, Buffalo, New York, 1951
Gelatin silver print
Image: 19 × 24.1 cm. (7 ½ × 9 ½ in.)
Sheet: 20.4 × 25.3 cm. (8 ¹/₁₆ × 9 ¹⁵/₁₆ in.)
Gift of the artist in memory of David Hunter McAlpin,
Class of 1920 (2001-168)

William Henry Fox Talbot, British, 1800–1877

Bridge of Sighs, St. John's College, Cambridge, 1844
Salt print from calotype negative
Image: 16.2 × 20.6 cm. (6 ⅜ × 8 ⅛ in.)
Sheet: 18.4 × 22.5 cm. (7 ¼ × 8 ⅞ in.)
Collection of Richard and Ronay Menschel

Shomei Tomatsu, Japanese, born 1930

The Path of the Wind, Nagoya, Aichi, 1951, printed 2000
Gelatin silver print
Image: 37.2 × 33.3 cm. (14 ⅝ × 13 ⅛ in.)
Sheet: 50.7 × 40.9 cm. (19 ¹⁵/₁₆ × 16 ⅛ in.)
Museum purchase, gift of Duane Wilder, Class of 1951
(2000-300)

Umbo (Otto Umbehr), German, 1902–1980

Night in a Small Town, 1930
Gelatin silver print
29.2 × 21.9 cm. (11 ½ × 8 ⅝ in.)
Lent by The Metropolitan Museum of Art. Gilman
Collection, Purchase, Ann Tenenbaum and Thomas H. Lee
Gift, 2005 (2005.100.153)

United Press International

Fresno County Courthouse, 1966
Gelatin silver print
Image: 22 × 16.9 cm. (8 ¹¹/₁₆ × 6 ⅝ in.)
Sheet: 22.9 × 17.6 cm. (9 × 6 ¹⁵/₁₆ in.)
Private collection

Unknown photographers, American

Homesteaders with claim shacks, 1907–1920s
36 gelatin silver prints on postcard paper
8.8 × 13.8 cm. (3 ½ × 5 ½ in.) each
Collection of Michael Williams

Unknown photographer, presumed British

Transporting a boiler, Ceylon, 1870s
Albumen print
23 × 28 cm. (9 1/16 × 11 in.)
Gift of Mrs. George Packer Berry in honor of her
husband, Class of 1921 and Charter Trustee of Princeton
University, 1956–1969 (2009-96)

Unknown photographer, French

Architectural view with people, ca. 1860s
Albumen print
Image (trimmed): 16.2 × 12.6 cm. (6 3/8 × 4 15/16 in.)
Museum purchase, gift of William J. Salman, Class of 1955
(1998-211)

Unknown photographer, French

Universal Exposition of 1900: Pavilion of the Transvaal, 1900
Cyanotype
32 × 26.5 cm. (12 5/8 × 10 7/16 in.)
Museum purchase, Fowler McCormick, Class of 1921,
Fund (2011-16)

Universal Exposition of 1900: Pavilion of Ecuador, 1900
Cyanotype
32 × 26.5 cm. (12 5/8 × 10 7/16 in.)
Museum purchase, Fowler McCormick, Class of 1921,
Fund (2011-17)

Robert Voit, German, born 1969

Norscot, Sandton, South Africa S26° 02.217 E028° 00.703,
from the series *New Trees*, 2006
Chromogenic print
Image: 51.5 × 41 cm. (20 1/4 × 16 1/8 in.)
Sheet: 62.3 × 52 cm. (24 1/2 × 20 1/2 in.)
Museum purchase, Fowler McCormick, Class of 1921,
Fund (2010-61)

Attributed to Wang Zhenpeng, Chinese, ca. 1280–ca. 1329

Late Yuan dynasty, 1260–1368
Pavilion of Prince Teng, 1312
Handscroll; ink on silk
Painting: 35.9 × 71.4 cm. (14 1/8 × 28 1/8 in.)
Museum purchase, Fowler McCormick, Class of 1921,
Fund, and gift of Giuseppe Eskenazi (2010-65)

Chris Ware, American, born 1969

Hold Still, 2005
Pen and blue pencil on paper
78.1 × 59.7 cm. (30 3/4 × 23 1/2 in.)
Courtesy Adam Baumgold Gallery

Carleton Watkins, American, 1829–1916

Pioneer's Cabin, 1865/66, printed 1876
Albumen print in the Ambroise Bernard Album
Image: 34 × 26 cm. (13 3/8 × 10 1/4 in.)
Album (open): 43.8 × 73.6 cm. (17 1/4 × 29 in.)
Lent by The Metropolitan Museum of Art. Gift of Carole
and Irwin Lainoff, Ruth P. Lasser and Joseph R. Lasser,
Mr. and Mrs. John T. Marvin, Martin E. and Joan
Messinger, Richard L. Yett and Sheri and Paul Siegel, 1986
(1986.1189.68)

Minor White, American, 1908–1976

Front Street, Portland, Oregon, 1939, printed later
Gelatin silver print
Image: 24 × 18 cm. (9 1/2 × 7 in.)
Sheet: 27.6 × 25.7 cm. (10 7/8 × 10 1/8 in.)
The Minor White Archive, Princeton University Art
Museum, bequest of Minor White (MWA 39-330)

John Willis, American, born 1957
*Mount Rushmore National Monument and the Sacred
Black Hills (Paha Sapa)*, 2007
Gelatin silver print
Image: 45.6 × 56.3 cm. (18 × 22 1/8 in.)
Sheet: 50.8 × 61 cm. (20 × 24 in.)
Promised gift of Richard S. Press and Jeanne Press

Max Yavno, American, 1911–1985

Aaron Siskind, Old Yuma Jail, 1947
Gelatin silver print
Sheet: 22.5 × 34 cm. (8 7/8 × 13 3/8 in.)
Mount: 38 × 50.5 cm. (14 7/8 × 19 7/8 in.)
Museum purchase, Fowler McCormick, Class of 1921,
Fund (2010-133)

Zhang Dali, Chinese, born 1963

Demolition — World Financial Center, Beijing, 1998
Chromogenic print
Edition 5/10
89.5 × 59.7 cm. (35 1/4 × 23 1/2 in.)
Collection of David Solo

Art Resource, NY: Rudy Burckhardt, Building front details, © 2011 Artists Rights Society (ARS), New York / The Metropolitan Museum of Art; Philip Henry Delamotte, *The Upper Gallery, Crystal Palace, Sydenham*, © The Metropolitan Museum of Art; Peter Keetman, *Baustelle (Building Site)*, © Peter Keetman. The Metropolitan Museum of Art; Werner Mantz, *School Interior: View from Stairway and Hall*, © 2011, Artists Rights Society (ARS) / VG BildKunst / The Metropolitan Museum of Art; PierreAmbrose Richebourg, *Barricades of the Commune, April 1871*, © The Metropolitan Museum of Art; Umbo, *Night in a Small Town*, © 2011, Artists Rights Society (ARS) / VG BildKunst / The Metropolitan Museum of Art

Paul Berger, *Europe #2*, © Paul Berger

Jeff Brouws, *Signs without Signification*, © Jeff Brouws / images courtesy the artist

Tim Davis, *Colosseum Pictures (The New Antiquity)* © 2009, Tim Davis / image courtesy Greenberg Van Doren Gallery

Julian Faulhaber, *Ceiling*, © Julian Faulhaber / VG Bildkunst Bonn / image courtesy the artist

Hope Gangloff and City Arts, *Forever Tall*, © CITYarts, Inc. Forever Tall, 2001

William A. Garnett, *Housing Development, San Francisco, California*, © 1953, Estate of William A. Garnett

Gordon Matta-Clark, *Splitting; Four Corners*, © 2011 Estate of Gordon Matta-Clark / Artists Rights Society (ARS), New York / image courtesy San Francisco Museum of Modern Art

Richard McGuire, *Here*, © Richard McGuire / image courtesy the artist

Richard Misrach, *White Man Contemplating Pyramids*, © Richard Misrach / image courtesy Fraenkel Gallery, San Francisco, Marc Selwyn Fine Art, Los Angeles and Pace/MacGill Gallery, New York

Andrew Moore, *Model T Headquarters, Highland Park*, © 2009, Andrew Moore / image courtesy the artist

Thomas Ruff, *jpeg co01*, © 2011, Artists Rights Society (ARS), New York / VG BildKunst / image courtesy the artist

André Souroujon, *Wish You Were Here*, © 2001, Andre Souroujon / image courtesy the artist

Art Spiegelman, *The New Yorker cover, September 24, 2001*, Art Spiegelman / The New Yorker. © Condé Nast

John Szarkowski, *Corner Pier, The Prudential Building, Buffalo, New York*, © 1951, John Szarkowski / Pace/MacGill Gallery, New York

Sze Tsung Leong, *Jiangsheng Cun, Shanxi Province*, © Sze Tsung Leong / image courtesy Yossi Milo Gallery, New York

Unknown photographers, American, Homesteaders with claim shacks, images courtesy Michael Williams

Robert Voit, *Norscot, Sandton, South Africa S26° 02.217 E028° 00.703*, © Robert Voit / image courtesy Amador Gallery

Chris Ware, *Hold Still*, © 2005, Chris Ware / image courtesy the artist and Adam Baumgold Gallery and *Hold Still*, New Yorker cover, © 2011, Chris Ware / image courtesy Condé Nast Publications

Carleton Watkins, *Pioneer's Cabin*, © The Metropolitan Museum of Art

DATE DUE